W9-DHH-295

Eerie SOUTH CAROLINA

*True Chilling Stories
from the Palmetto Past*

—〜〜〜〜—

SHERMAN CARMICHAEL

ILLUSTRATIONS BY KRISTEN SOLECKI

THE
History
PRESS

Published by The History Press
Charleston, SC 29403
www.historypress.net

Copyright © 2013 by Sherman Carmichael
All rights reserved

First published 2013

Manufactured in the United States

ISBN 978.1.62619.214.0

Library of Congress CIP data applied for.

Notice: The information in this book is true and complete to the best of our knowledge. It is offered without guarantee on the part of the author or The History Press. The author and The History Press disclaim all liability in connection with the use of this book.

All rights reserved. No part of this book may be reproduced or transmitted in any form whatsoever without prior written permission from the publisher except in the case of brief quotations embodied in critical articles and reviews.

CONTENTS

Contents

ACKNOWLEDGEMENTS

Beverly Carmichael, for her many hours of correcting my mistakes. For all the help from Ric Carmichael, James Ebert, April Asaro and Lynne Ebert. Timmy Brigham, Cindy James and Becky Dunahoe, for leading me to a story. Dwight Dana, the *Florence Morning News*, Mike Atkinson, Noonie Stone, Angie Wilder Stone, David Bennett, Luke Anderson, Ann Van Emburg, Sandy Gibson, Barbara Bush and Jack Smith, for their stories.

JUST A THOUGHT

South Carolina is known throughout the country for its southern hospitality, its frequent hurricane attacks and the greatest barbecue this side of anywhere. The state also plays host to millions of visitors each year—living visitors, that is. But what a lot of people don't want to believe is that South Carolina also has many other visitors from the old, old, old South. South Carolina is rich in history, folklore, ghost stories and many other strange things.

It's not unusual that we're being visited by spirits from the past. With our violent and turbulent history, it's no wonder these restless spirits still watch over the places they loved.

South Carolina is one of the thirteen original colonies of the United States. It was founded in 1663. But with the arrival of the settlers came diseases that almost wiped out the local Indians. In 1670, the English colony of the Province of Carolina was started in Charleston. Colonists overthrew the proprietors after the Yamasee War. In 1719, the colony was officially made a crown colony. North Carolina was separated and made into a separate colony in 1729.

South Carolina opposed the British taxation in the Stamp Act of 1765 and played a major role in resisting Britain. On March 26, 1776, South Carolina set up its state government and constitution

and became independent. The Revolutionary War was a hard-fought, bloody war, and many people lost their lives.

After Abraham Lincoln was elected president in 1860, South Carolina was the first state to secede from the Union on December 20, 1860. The firing on Fort Sumter on April 12, 1861, started the Civil War, a conflict that would leave thousands on both sides dead. The wartime destruction almost ruined South Carolina's agricultural economy.

Ghosts, spirits and apparitions—or whatever handle you put on them—have been around for as far back as recorded history. One theory is that these wandering spirits are the dead returning in some form from the past to the present.

Just suppose that all of the ghosts are not the remains of the dead. Let's look at another theory: time travel. Einstein said that it's not possible. But just suppose that someone did find a way to travel back into the past or into the future. Some theorists say that the past doesn't exist anymore and that the future hasn't come yet. What if they're wrong?

Since the 1940s, secret government agencies and civilian groups have been experimenting in time travel. One experiment was called the Montauk Project. Suppose the people involved found a way to bend time or create a portal or vortex through which a person could move through time and return to where he started from. What would happen to that person if there was a glitch in hyperspace or the equipment lost power? The time traveler would be lost somewhere. According to unconfirmed reports on the Montauk Project, many time travelers were lost in time. But where? In the past, the future, somewhere in between or in another dimension? It's all speculation at this time. Did the lost time travelers keep their physical bodies, or were they changed? Thousands of people have been reported lost in the Devil's Triangle. Where are they? Could some of those things that we see be the remains of lost time travelers? Is it possible that the spirits that we see are stuck in time and continue to travel to a destination that they will never reach?

Another theory is the apparitions that haunt a specific location may not be the spirit of the dead but rather could be the images of

a past tragic event frozen in time and replayed over and over again. What the person is witnessing, then, is a glimpse of the past rather the spirit of a dead person.

NORTHWEST

THE HAUNTINGS AT CONVERSE COLLEGE

Converse College has the reputation among some ghost enthusiasts as being the second-most haunted place in South Carolina. It does seem to have a number of residents from the other side. The Hazel B. Abbott Theatre is reported to be the most haunted location on campus. It is located on the third floor of Wilson Hall on the Converse College Campus in Spartanburg, South Carolina. The 279-seat proscenium theater has served as the home for local productions for more than one hundred years. The theater is located in Converse College's original main building. The theater also serves as a classroom for the college's courses in acting.

Converse College was established on October 1, 1890. Dexter Edgar Converse began the planning stages in 1889. Converse's daughter, Marie, was about old enough to attend college, and Converse wanted the very best for his daughter. So, he decided to start a women's college.

The first class held at Converse College consisted of sixteen faculty members and 168 female students. The future outlook for Converse

College was good. The college was founded on the idea that "the well being of any country depends upon the culture of her women."

Disaster for Converse College was just around the corner, though. On January 2, 1892, a fire destroyed the main building. Reconstruction started immediately on the building, and it was enlarged. The annex building constructed in 1861 was not damaged by the fire. It was the second building built on the campus and was named Pell Hall. Pell Hall has served many functions since it was built. Now it serves only as a dorm.

In 1896, by a voluntary act of the stockholders, Converse College was incorporated under the laws of South Carolina, and a self-perpetuating board of trustees was formed. Converse College was converted into a permanent gift to the cause of higher education for women.

In the 1900s, new buildings were constructed and the best teachers were acquired. Converse College grew into one of the best colleges for women in the South. During this period, Converse's school of music received a national rating as a professional school of music. The college became a charter member of the National Association of Schools of Music.

In 1983, Converse College introduced Converse II to fit the needs of adult women.

In 2003, the college completed its most successful capital campaign in the college's history. It received $82.5 million in private gifts.

Among Converse alumnae are a Pulitzer Prize winner; a well-known heart researcher; a Texas Supreme Court justice; a prominent civil rights attorney; Broadway performers; the deputy crew commander for Titan IV rocket launches at Cape Canaveral, Florida; and the first female circuit court judge in South Carolina.

Past presidents for Converse College include Benjamin F. Wilson (1890–1902), Robert Payne Pell (1902–32), Edward Mosley Gwathmes (1933–55), Oliver Cornwell Carmichael Jr. (1956–60), Robert T. Coleman Jr. (1961–89), Ellen Wood Hall (1989–93), Sandra C. Thomas (1994–98), Nancy Oliver Gray (1999–2005) and Elizabeth A. Fleming (2006–present).

The Other Side of Converse College

It seems that there are a number of haunted buildings on the Converse College campus. Each building is haunted by a different ghost. No one seems to know the reason for the return of these restless spirits. Some of the spirits are reported to be friendly, others are much less so.

Hazel B. Abbott seems to have taken up residence in the theater named in her honor. Some people report that the theater is always very cold no matter what time of the year it is. Some note that when you enter the theater, you can feel a cold presence inside. Others report that when you sit in Hazel's seat, she will haunt you for a while. People have also reported hearing strange noises in the prop room. Some say that Hazel B. Abbott is not too friendly, while others have not had any problems with her ghost.

The stairway in Wilson Hall is another location that is visited by a spirit. It seems that an argument ensued between two men on the stairway. One of the men pushed the other man off the stairway, and he fell to his death. There are reports of an angry ghost with red eyes on this stairway.

Pell Hall is the location of a tragic accident—or was it an accident at all? Two young people had made plans to get married via an elopement. The girl was going to jump from her window into the waiting arms of her lover. He had promised to catch her, but he didn't. She fell to her death at his feet. You can still see a lovely young lady dressed in a white dress running down the hall. People have experienced some strange goings-on in the girl's room, such as hearing loud bangs and seeing a girl dressed in white standing over you when you're in bed. Today, the door is kept locked and off-limits to the students.

Another strange happening in Pell Hall is the sighting of a mysterious outline of a girl named Betty. She hanged herself from the door in her room. No matter how many times or what color you paint the door, the outline of a girl with a rope around her neck will eventually reappear. The ghost of Betty has from time to time locked people in her room.

Williams Dorm is said to be haunted by the ghost of a little boy. The legend is that the boy haunts the laundry room. Some reports

say that you can throw a ball down the hall, and he'll throw it back to you. He is reported to be a very friendly ghost. In my research, I could not find where anyone had died or been killed on the Converse College campus.

THE SCHOOL FOR THE DEAF AND BLIND

In the recent years of the growing popularity of ghost hunting TV shows, many stories have been circulating worldwide about haunted schools. Haunted schools are a favorite place for local ghost hunters. There are many ghost stories that surround these educational facilities. Some ghost hunters believe that it's the spirits of the children who died while attending school that still haunt

these buildings and grounds. Some believe it's the teachers, moving somewhere between the spiritual realm and the physical plane. Other paranormal investigators are not sure what is haunting these buildings or why. The one thing they can agree on is that there are a lot of haunted school buildings. Apparitions, voices and many other sounds from the other side have been associated with some schools. Many of these haunted schools are nothing more than forgotten, abandoned buildings. Some of the schools were converted from hospitals and other buildings that may have seen a lot of tragic events unfold over the years.

One school that is reported to be haunted and still in use since 1849 is the School for the Deaf and Blind. In the 1840s, Reverend Newton Walker saw a need for a school for the deaf. Walker and his wife, Martha Hughston Walker, had three children who were deaf. With no schools for the deaf in South Carolina, the nearest one being in Georgia, Walker had to travel there and learn the methods for teaching the deaf.

Walker set out to open a school for the deaf in South Carolina. On January 22, 1849, Walker opened his school in Cedar Spring in southeastern Spartanburg County. The school was housed in an old hotel that was no longer in use. The school opened with five deaf children and a small group of children who could hear.

In the early years of the school, it was privately owned by Reverend Walker. The cost of running the school increased every year. By 1854, the cost of running the school had finally became so great that Reverend Walker could no longer run the school alone. He had to look for other avenues and funds.

In 1856, Walker convinced the South Carolina legislature to take over the school and run it as a state-supported school. The state allocated $30,000 to build a new building, which would later become known as Walker Hall.

During the first years of operation, Reverend Walker saw a new need for a school for the blind. In 1855, a separate department for blind children was added. James Henderson, a graduate of the Tennessee School for the Blind, acted as the first principal. In 1977, a school was opened for multi-disabled children. These children had handicaps other than being deaf or blind.

In 1979, a private fundraising foundation was established and named the Foundation for the Multi Handicapped, Deaf and Blind School of South Carolina. The foundation was later named the Walker Foundation. In 1984, a relationship was created with twelve local schools to begin an outreach service program. Since then, the outreach services have expanded statewide. Some programs include early intervention, vision and hearing services in public schools, the deaf and blind project and sign language interpreters. A Braille and large-print distribution center has also been established.

In 1984, the vocational facility opened, giving students an opportunity to learn employment trades and skills. In 1996, the state-of-the-art Cleveland Learning Center opened. In 2001, the South Carolina School for the Deaf and Blind changed the name of the vocational department to the career technology and education department.

In 2004, the Hughston Transition Living Center was opened. This center was designed so that all students, regardless of what disabilities they may have, could live there self-sufficiently. The building was named in memory of John M. Hughston. He was the first graduate of the South Carolina School for the Deaf and Blind.

In 2007, an early childhood development center was opened. It was named in honor of Marcia Kelly. The center is a partnership between the South Carolina School for the Deaf and Blind and the Spartanburg County First Steps Early Head Start program. In 2010, the South Carolina School for the Deaf and Blind dedicated a 320-seat sports complex.

The South Carolina School for the Deaf and Blind is located on 160 acres four miles from Spartanburg. The campus includes forty buildings, classrooms, libraries, vocational training centers, dormitories and recreational facilities, as well as at least one resident ghost.

During the Civil War, Martha Walker's oldest son went off to join the service. During this time, Reverend Walker and their three-year-old son both died. Martha was left to run the school by herself. During the Reconstruction period of the Civil War, Martha closed the school temporarily. When it reopened, Martha's brother took

over. Martha still remained on the campus, though. She lived in a room on the first floor of Walker Hall. Martha Walker passed away in 1900. Some believe that even after her death, Martha Walker never left Walker Hall. Some believe that Martha Walker is still walking the halls in the old historic building, part of which is known as Walker Hall. Some believe that she is watching over the students. Others, though, believe that she haunts the school because she was never named as president.

There have been reports of disembodied voices, shadowy figures and the sounds of footsteps walking up and down the hall. No one has ever been seen when the footsteps are heard. Some have reported seeing the apparition of Martha Walker standing on the staircase in Walker Hall. Some encounters with Martha Walker on the third floor have been reported. Why is Martha Walker still haunting Walker Hall?

THE ABBEVILLE OPERA HOUSE

The Abbeville Opera House originated as a one-night stopping place for traveling New York road companies on their way to the bigger cities. These performances were gala events, with people turning out in their finest attire. After seeing the success of the overnight stops, some Abbeville citizens thought that if it had a theater, Abbeville could sponsor some of these touring companies.

The Abbeville Opera House opened on October 10, 1908, with the performance of *The Great Divide*. Between 1908 and 1913, the Abbeville Opera House hosted about 260 live performances.

The Abbeville Opera House had a 7,500-square-foot stage that could accommodate most any performance. The opera house offered a variety of vaudeville, minstrel and burlesque shows, along with Broadway's most popular musicals and plays.

Live performances slowly began to fade away with the introduction of moving pictures as early as 1910. The Abbeville Opera House

continued the live theater along with the silent moving pictures. From 1914 to 1930, it is estimated that more than 3,250 moving pictures played in the opera house.

In 1927, *The Jazz Singer* played in the opera house, and that marked the beginning of canned entertainment. The opera house remained a theater until the late 1950s. Like many theaters, it started losing money and was forced to close. Ten years later, the Abbeville Community Theatre (ACT) visualized the potential of the old abandoned opera house. To celebrate the return of the Abbeville Opera House, *Our Town* was presented on stage in May 1968.

In 1979, a professional touring company under the guidance of Michael Genevie established residence at the opera house. Under Genevie's leadership, the theater has been awarded the South Carolina Governor's Travel Award for Tourism. It was also designated as the official state theater of South Carolina. Today, the opera house is fully restored to its turn-of-the-century splendor. Two major improvements have been made to the theater, air conditioning and rocking chair seats.

The world of theater is full of superstition, and almost all old theaters are home to a ghost or two. Not many theaters have a specific chair for their ghost, but the Abbeville Opera House does. It has a single empty chair in the second balcony specifically for the ghost.

During a standing ovation once, an actor looked up to the balcony and saw a lady in turn-of-the-century clothes applauding. The chair is kept up there for that lady. The story goes that an actress fell ill after she got off the train and died shortly after.

They believe that if you move the chair, something will happen during the play—the curtain won't go up, something will fall or the lights will go out. People have reported hearing strange noises in the theater when they were by themselves. Others have reported seeing something move over to the side of the stage, but when they looked, nothing was there. Some have heard footsteps on the catwalk. A former stage manager forgot something in the theater and had to go back in to get it and saw people in costume on the stage.

The Abbeville Opera House continues to have live performances that are applauded by the living and perhaps even the dead.

THE SULLIVAN MUSIC BUILDING

The paranormal world is full of unsolved mysteries. Ghosts, spirits and other entities that have returned from the grave will always be on the top of the list. These apparitions have baffled mankind from the beginning. Regardless of what these entities are, where they come from or what their purpose is, there's one thing for sure: we are not alone.

Many believe that these unearthly visitors remain on earth after the physical body expires. Another theory is the soul doesn't know it's dead. Whatever their purpose is, these entities keep returning. Are these visitations just an echo from the past?

The Sullivan Music Building has a long history. It was built between 1911 and 1914 and donated to Anderson College in 1914 by Charles Sullivan Sr. The building was used as the president of Anderson College's home until sometime in the 1940s. In 1965, the building was renovated to be used for the music building and is now used as the home to the Baptist Campus Ministries. It also houses several other offices.

Anderson College, like many other colleges, has its resident ghost—at least that's what some say. The college denies that any of its buildings are haunted. It also denies that anything tragic ever happened in the music building or anywhere on the campus. Since officials deny that the haunting ever happened, there is seemingly no basis for the story. I couldn't locate much information on this haunting at the Sullivan Music Building or the ghost Anna's last name.

Anna was a sixteen-year-old girl, the daughter of one of the former presidents of Anderson College. Like many sixteen-year-old girls, she fell in love. He was a young Catholic boy named Francis. Needless to say, her father didn't approve of the boy. Anna's father believed that she was too young to marry, and he didn't give his permission to Anna to marry Francis. So distraught that she couldn't marry her true love, Anna threatened to commit suicide unless her father changed his mind and agreed to the marriage. Her father still refused to allow the marriage.

Anna had planned to fake the suicide by hanging herself from the staircase in the foyer of the Sullivan building. Unfortunately, the trick suicide failed, and Anna accidently hanged herself.

Many of the stories of the ghost of Anna come from an upstairs room. People have reported hearing someone playing the piano or a young girl singing. Some have heard footsteps above them or walking on the wooden staircase from which Anna hanged herself. Some say that they have seen the ghostly figure of a young girl with an expression of deep sorrow. Another story is that a male student encountered the semitransparent figure of a young girl playing the piano. There have been reports of lights coming on and going off by themselves.

Some believe that the story of Anna's ghost was cooked up to promote a haunted house fundraiser in the early 1980s that was held in the Sullivan Music Building. As you were escorted through the haunted house, the guide would tell you the story of the ghost of Anna. Perhaps not so coincidentally, the story of Anna started circulating in the 1980s.

Anderson University is located in Anderson, South Carolina.

GAFFNEY'S T BRIDGE

Once again, dear readers, as we journey through South Carolina in search of the strange and unknown, we come across another haunted bridge. It seems that just about every neighborhood has a haunted bridge and some sort of a ritual that goes along with it. Could tragedies have happened on all of these bridges that left the lingering effects of trapped spirits or those that have decided not to move on?

I could not find any information on this bridge to justify a haunting of this nature, but I'm not saying that something *didn't* happen. Gaffney's T Bridge was built in 1919, and after years of neglect, it is in need of some serious repairs. It is said that if you run across the bridge without stopping, a car will come behind you with no driver inside.

THE HAUNTING OF LYDIA MILL

The South is known for an unusual amount of sorrow and tragedy since the first inhabitants roamed the lands. Many suicides, murders and lingering deaths have happened. Some of these victims are still hanging around, refusing to leave, or have lost their way and cannot move on. Is this the case of the ghost of Lydia Mill? On hot summer nights as well as cold winter evenings here in South Carolina, ghostly things sometimes happen that defy explanation. It is those events that lead to lasting ghost stories.

Mercer Silas Bailey was born on November 9, 1841, in Laurens County, South Carolina. He was the youngest son of Silas Mercer and Margaret Bailey. There were seven children in the family, three sons and four daughters. The family homestead was located near Little River, just a few miles west of Clinton, South Carolina.

Mercer was educated at the Laurensville Male Academy. He fought in the Civil War but was discharged in 1862 due to an injury. He became the founding father of Clinton and a businessman. Mercer started M.S. Bailey and Sons bank. He was also the founding father of the Presbyterian College. Bailey and Dr. Plummer Jacobs organized the Thornwell Orphanage, which is now the Thornwell Home and School for Children.

Through the visionary work of Dr. Plummer Jacobs, Bailey turned to the textile industry. On February 1, 1897, Clinton Cotton Mill was opened. Bailey took the position as president, and his son William was appointed the secretary-treasurer. Outside Clinton, there is a community called Lydia Mill. On March 10, 1902, Bailey's

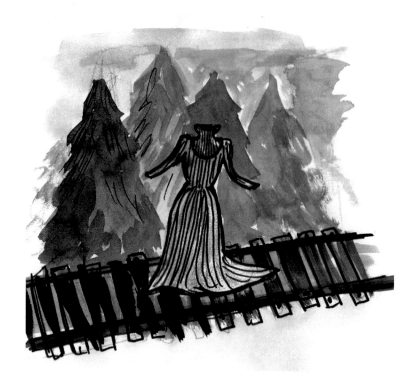

second mill complex was chartered. The mill was named Lydia Mill for his deceased wife, Rosanna Lydia. Bailey served as the president of the mill, and his son Cad was the secretary-treasurer.

The mill owners built houses for their employees. This made the mill owners their landlords as well as their employers. The mill owners also owned the mill store, where their employees shopped. The employees were kept poor, while the mill owners grew wealthy. Most of the employees lived in the milltown. The Lydia Mill was located on the outskirts of the community. The Lydia Mill village was developed and owned by the Bailey family until about 1965.

Near Lydia Mill is a graveyard that has seen some strange happenings. People who live near the graveyard talk about the ghost of a woman who was murdered on the site of Lydia Mill. No one knows why she was murdered or by whom. The woman's headless body was found by the railroad tracks. The ghost of the headless

woman is supposed to haunt the old mill building and places near the railroad tracks where her body was found.

People also report that if you drive down the road to the graveyard, the ghost of a woman will appear in the middle of the road right in front of your car. She appears so quick and close to the car that there is no time to take action to miss her. When the driver stops to check on her, there is no one there.

THE DEVIL'S CASTLE

Located on 126 Beverly Road just minutes from Greenville, South Carolina, is a 1,275-acre park. This park is excellent for all of your outdoor activities, if you don't mind being joined on your picnic or hike by a few wandering spirits. From time to time, these restless spirits leave their home at the Devil's Castle.

The Devil's Castle is the remains of a 36,949-square-foot building once used as Greenville's Tuberculosis Hospital. The hospital was opened on July 27, 1930. The doors closed for the last time in the 1950s. The 1950s saw the development of antibiotics that could fight TB, ending the need for this type of hospital. The building sat abandoned for a short time and then was converted into a hospital for the criminally insane. Many of the prisoners were treated badly and not given enough food and clothes. Many died in the building. The building was left abandoned until 1974, when it was turned into a work release center for prisoners. This ended in 1997.

Many people reported seeing dark, shadowy figures moving about the windows and in different locations in the park. Mysterious flickering lights could be seen moving around inside the building. Footsteps had been heard inside the building and around the outside of the building, but no one could be seen.

Who or what were the flickering lights, shadowy figures and strange sounds coming from the Devil's Castle? Were they the souls of the TB patients or the insane trying to find their way home?

In November 2002, a group of homeless people trying to stay warm in the bitter cold set fires in paint cans, destroying the seventy-five-year-old building.

THE GHOST OF HENRY GALBREATH

During the death and destruction in South Carolina during the Revolutionary War, a time of darkness settled over the state. Hope for independence was slowly fading away. During this turbulent time, young men in South Carolina were heroically joining the cause. Henry Galbreath was no different. Galbreath, who lived along Bush River, went off to join those fighting for South Carolina. He made a promise to the girl he loved to return to her alive or dead—but he would return nevertheless.

Galbreath was a courageous young man, well versed in the area around Bush River and most of South Carolina. He spent much of his life in the woods, so this would be nothing new to him. Galbreath was wanted by the Tories in the area, so he could only be with the one he loved during the night. Just before dawn, he would be forced to leave her and return to the woods.

They met for the last time, and Galbreath told her that he was going to join the Continental army. Little did she know that his last words to her were, "No matter what, I'll be back to see you in a year, alive or dead." In July 1780, under the darkness of a cloud-covered moon, Henry Galbreath left to join the cause for freedom. His love was left standing alone in their secret meeting place, not realizing that this would be the last time she would see him.

Galbreath joined General Horatio Gates in the defeat at Camden, South Carolina. He later joined and fought with Francis Marion for a while. He later joined and became a scout for William Washington's cavalry. His knowledge of the area made him a legend with the British as well as the Americans.

In January 1781, the war began to turn in favor of the Americans, but for Henry Galbreath, he would not live to see neither the victory

nor his love again. At the Battle of Cowpens, the British began to retreat an hour into the fight. As the British continued to retreat, a lone horseman began giving chase. One of the British soldiers turned and fired a single shot at the lone horseman, hitting him in the heart. Henry Galbreath, falling from his horse, died fighting for his country.

Galbreath's love knew nothing of his death; she was not notified that he would not be returning home. As the day of his promised returned dawned, she continued to do her chores around the house. Every so often, she would look out the door in the hopes of seeing him coming down the road. The day passed without his return. As night fell over the countryside, she headed to bed, despondent over Galbreath not arriving like he promised. Sleep would not come easy that night. Her head was full of thoughts of what might have happened and hopes that he would return tomorrow.

Finally, she drifted off into a restless sleep. No sooner had she fallen asleep than she was awakened by the sound of a horse. She listened

as the horse drew nearer to the house. It stopped outside her window. She opened the window and looked out to see a man dressed in a long dark-blue cape looking at her window. Before she could say anything, the horse and rider turned, and off they went down the road, disappearing into the night. The next morning, she and her family searched outside for hoof prints, but none was found. She knew that Henry Galbreath had kept his promise. He returned one year later.

HAUNTED BRATTONSVILLE

In 1776, William Bratton bought two hundred acres of land on the south fork of Fishing Creek from Thomas Rainey. The land Bratton bought was in what was then Mecklenburg County, North Carolina. Bratton was already living on the property when he bought it. The whereabouts of the Bratton family before their move to Fishing Creek are unclear. What is clear is that the Brattons' ancestors were immigrants from Ulster Province in Northern Ireland. The Brattons were part of a large Scotch-Irish migration to America in the first half of the eighteenth century.

There are records that indicate that the Brattons were living in Augusta County, Virginia, as early as 1740. William Bratton's wife, Martha Robinson (or Robertson; the last name is unclear), was also Scotch-Irish. The Bratton family records state that William Bratton was born in Ireland and that Martha was born at sea during the Atlantic crossing. There is no recorded date of the marriage between William and Martha.

There is also no recorded date for when the Bratton house was built. It is believed that it was built in 1776. By 1780, William and Martha Bratton and five children were living in what is now known as the William Bratton Home. For many years, the Bratton residence was a single-pen, story-and-a-half log house (see note at the end of this section). There were a few shuttered windows.

At the time of the American Revolution, Bratton was a significant citizen in the New Acquisition District of South Carolina, now

known as York County. In 1776, Bratton was appointed a justice of the peace and, in 1777, a tax collector.

In the New Acquisition militia, Bratton served as a captain, a major and a colonel. The New Acquisition played an important role during the American Revolution. Men from the New Acquisition served in all the important battles in South Carolina between 1775 and 1783.

Huck's Defeat

In the spring and summer of 1780, the Revolutionary War was at full force in the area between the Broad and Catawba Rivers, the area now know as York and Chester Counties. The New York volunteers and a troop of British dragoons under Captain Christian Huck were dispatched in June 1880 to destroy the militia at Fishing Creek Church and Hills Ironworks. Huck accomplished this with ease. Loyalist George Turnbull gave Huck instruction to apprehend McClure and Bratton and disperse the rebels in the upper Fishing Creek and Bethesda communities. Bratton and McClure learned that Huck was on the rampage again, and plans were made to intercept him. Bratton and McClure believed that Huck was camped at Walker's Mill in Chester County. They set out to ambush Huck and the loyalist Turnbull. Colonel Edward Lacey from Chester County and Colonel Andrew Neal from York County gathered men from their location to intercept Huck.

On July 11, Huck and his army arrived at the Bratton home. One of the men threatened Bratton's wife to try to get the location of William Bratton. She refused to give the location to the Loyalist. Huck later arrived and questioned Martha Bratton. She still refused to give Huck Bratton's location. Unable to get the needed information, they moved on to the home of James Williamson. Huck needed the food on Williamson's farm for his horses.

When the Whigs learned that Huck had camped at Williamson's home, they decided to attack there. They moved into position at night, and just as the first light of day shone down, the Whigs attacked. Huck's men were caught by surprise. With nowhere to go,

some fled into the woods. Many surrendered without a fight. John Carroll took aim and fired at Huck, killing him instantly. The battle was over in about ten minutes.

After the American Revolution was over, Bratton continued to prosper socially, politically and financially. In 1784, he was appointed tax collector for a second time. In 1785, he became for a second time a justice of the peace. In that same year, Bratton became a district representative to the South Carolina House of Representatives. He held that position until 1790. In 1791, he became a state senator and remained in that position until 1794. In 1795, he became the sheriff of the new Pinckney district. At some point, Bratton acquired a cotton gin and joined the cotton farmers in the area.

On February 9, 1815, William Bratton passed away. Wife Martha Bratton died a year later on June 16, 1816. Both are laid to rest at the Bethesda Presbyterian Church Cemetery in York County. In 1971, the William Bratton Home and the homestead house were listed on the National Register of Historic Places. In 1976, they were opened to the public.

Historic Brattonsville is a 775-acre historic site that includes a Revolutionary War battlefield. Some people report that if you walk through the battlefield, you can still hear and feel the spirits of the soldiers who lost their lives there. There are some reports of people hearing metal banging together and seeing a light in the blacksmith shop.

The battles ended long ago, and the war is over. But is it over for everyone? The sounds of muskets and cannon fire are distant memories. For some, the ghostly sounds of cannon or musket fire can still be heard in the distance. The souls of these long-departed soldiers are still walking the battlefields of South Carolina, waiting for the call to retreat that will never come. Are the lonely spirits destined to walk the battlefields forever, or will they one day be called home? Ghosts defy all rational explanations. The mysteries of the dead appear to have no other explanation; they are just here.

Note: A single-pen log cabin has a single room with one door and a few windows. Window glass was often not readily available, and mosquito netting or shutters were employed to keep out insects, making for a dark interior. A stone or block chimney was often placed at one of the gable ends of the house. A broad porch provided a relatively cool spot to sit.

NORTHEAST

LOWTHER'S HILL CEMETERY
(AKA MONTROSE CEMETERY)

Mount Pleasant Baptist Church was established in 1785. One source refers to the church as Montrose Church, established in 1785. The congregation originally met in a nearby school. They built the sanctuary in 1791. Later that same year, Cashaway Baptist Church merged with Mount Pleasant Baptist Church. The original church, built on the Pee Dee River, burned down in the early 1800s.

It was rebuilt and the name changed to Mount Hope Church. Mount Hope either burned down or was flooded. The location of the church was moved to higher ground, and it was rebuilt. The church was later abandoned because it was believed to be built on unholy ground. The church was moved about two miles south to Mechanicsville, which is located in Darlington County, and was renamed Mechanicsville Baptist Church. No evidence of the original churches remains today.

Montrose Cemetery was started in about 1789 and continued to be in use until 1956. Some prominent people laid to rest in

Montrose Cemetery include Major Robert Lide (1734–1802). Lide was an officer under General Francis Marion. Captain Thomas E. Hart (1796–1842), whom Hartsville is named after, along with state representative John Westfield Lide (1794–1858), were also laid to rest in Montrose Cemetery. Many soldiers from the Revolutionary War and the Civil War found their final resting place there. Many of the settlers from that area are also buried there.

Mr. and Mrs. Clarence Lee Atkinson Sr. donated the cemetery to the Darlington County Historical Society. A historical marker number 16-61 was erected there in August 2010 by the Darlington County Historical Commission.

There are a number of ghost stories relating to the Montrose Graveyard. One story is about a little boy wearing gray antebellum clothes standing behind one of the few remaining tombstones. The name on the tombstone is Joseph Wallace. While some people were taking rubbings of the gravestones, they heard the sound of a child's laughter. When they looked around, they saw what appeared to be a small boy standing in front of a tombstone. When they walked over to get a closer look, the small boy laughed again and slowly disappeared. The name on the headstone was Joseph Wallace (1822–183?; the rest of the date was broken off).

Most of the headstones and grave markers have been broken, and many graves have sunk in. There have been reports of the temperature being much colder once you enter the gate.

In the 1950s and '60s, Montrose Graveyard became the local haunted graveyard. Teenagers started kicking over, destroying and stealing the tombstones. There was so much vandalism in the graveyard that the Darlington County Historical Society removed the headstones and placed a large marble stone marker outside the entrance with the names of each person who was buried there engraved on it.

Today, the cemetery is being taken care of by the members of the Cashue Ferry Organization of Old Timers (COOTs). Do not trespass on or vandalize this property or any other property. Get permission before you go there, or you could get arrested.

The following story was brought to my attention by Timmy Brigham. It is reprinted in its entirety with the permission of the

original author, Dwight Dana and the *Florence Morning News*. And now here's the rest of the story.

"APPARITION IN MECHANICSVILLE GRAVEYARD WAS A LATE 1950S TERROR…AND THEN, A SHOT RANG OUT…"

MECHANICSVILLE—Ever hear the tale of Montrose, the 8-foot tall haint who hung out at a spooky, moss-draped Darlington County cemetery in the late 1950s and early 1960s, scaring the daylights out of those who ventured there?

Gather round, kids. Turn off that flashlight.

Montrose was a real monster who scared innumerable people who dared tread on his sacred ground. He scared several denizens so badly that they ran down the dirt road that led to his lair and all the way back to Darlington on foot, via the Mechanicsville Highway. That's a pretty fair piece, but it's not so far when you're running scared.

The very name of Montrose made the blood run cold in many a vein. But then, just as his legend was rising, he disappeared into the mists from which he came.

It would be nice to relate the Montrose legend, something about a murder, or a missing head or something, but a different tale must be told. The truth must come out. This reporter has learned after all these years who Montrose is and why he faded away for good (we think) one Halloween long, long ago.

LIKE MOVIE SET

Montrose, as it turns out, was all made up. He was the brain child of Arnold Floyd of Hartsville and Rudy Lewis of Evergreen, both Darlington natives. Although they played the part to perfection, they didn't come up with the name, or, to be honest, the whole Montrose invention.

But they did make the most of it.

Floyd is retired from Sonoco as a chemist after 48 years. He's still young at heart, driving a black 2008 Corvette with the biggest engine possible and a shifty, 6-speed transmission.

"We decided it was time to scare some people on Halloween around 1959," Floyd said during an exclusive cemetery interview Tuesday morning. "We would take unsuspecting people out to the cemetery at night."

The cemetery—we'll keep the exact location a secret, seeing as how the folks buried there aren't Montrose fans—was perfect for a good scarin'. It had a wrought-iron fence, a creaky gate and weathered tombstones, leaning at different angles. The backdrop was huge oak trees with moss dripping all the way to the ground. It was, and is, like a spooky movie set.

Floyd and his possessed allies had the eerie scene planned down to the last supernatural detail. There would be ghosts of the past hiding behind the tombstones. The unaware would tread cautiously through the creaky gate, some with flashlights. Headlights from two cars would be shining in the cemetery, lighting their way. And then, at the appointed hour, just as the victims got into the cemetery proper, a ghostly scream would break out and the lifeless would slowly emerge from behind the tombstones.

"Then, just as they were getting the daylights scared out of them, the lights in the cars would go off," Floyd said. "Those with flashlights would rush for the gate with the others following."

And that is where Montrose came in.

A Scare for Montrose

Floyd and Lewis would lurk just beyond the gate, Floyd standing on Lewis' shoulders, making the combined creature appear at least 8 feet tall. Floyd, on top, was wearing a fiendish mask, huge rubber gloves and a gown that stretched all the way to the ground.

"That's when everybody really started getting afraid," Floyd said. "They ran in every direction."

Floyd and Lewis enjoyed their role as Montrose to the max for three years. Then they got the scare of their lives.

"We were late getting to the cemetery that last time," Floyd recalled. "We climbed up the steep hill that is beside the cemetery and got into place. A shotgun went off and I jumped off Rudy's shoulders. Montrose for us was no more after that. We got the wits scared out of us."

The end of Montrose's tale?

Well, not quite.

For the rest of the story we turn to Paul Howle, a retired editorial writer for the Atlanta Constitution. It was Howle, a 1958 graduate of St. John's High School, who came up with the name Montrose, and the Montrose concept, in the first place.

"I got the name from a store somewhere on the road to Cheraw," Howle said late Tuesday. "I had a summer job at the Moore Brothers warehouse that summer. This would have been 1957.

"Jim Kilgo, Huby Thompson, Freddie Dargan (all deceased) and I cooked up the ghost story," said Howle. "We would take girls out there and scare them."

Montrose's eventual demise was foreshadowed during one of the early, casual hauntings. Howle and company were out at the east Darlington cemetery mentioned above, impressing the girls with their haunting skills, when things got a little out of hand.

"One night we went out there with a bunch of boys," recalled Howle. "(The late) Billy Atkinson was hiding in the bushes, and when he started making scary sounds, somebody shot a pistol at the 'ghost' and grazed Billy in his hand.

"Richards Wilson was there and jumped off the hill. He said he was going home to get a silver bullet, which was the only thing that would stop a ghost. Then we all convoyed to Wilson's Clinic to get Billy's hand looked at."

Howle said nobody ever realized what all this would turn into…a fully staged haunting, a giant Montrose and…an enduring legend.

"Ghost hunters from everywhere have been out there and declared that they can sense a 'presence' there," said Howle. "Utter nonsense."

Montrose might not agree.

Dwight Dana passed away shortly after he wrote this article.

THE STRAND THEATRE

The plot of land now occupied by the Strand Theatre in Georgetown, South Carolina has been occupied by a theater since 1914. The Peerless Theatre was the first to be constructed there. It was short-lived but was later reopened as the Princess Theatre. The Princess Theatre was sold in 1929 and reopened once again as the Peerless Theatre.

The Strand opened in 1941, giving the locals a chance to take a vacation from reality. Movie theaters were designed to transport moviegoers into a world of make-believe. They can transport you into the distant past or the far future without you ever leaving your seat.

In 1941, the Strand Theatre opened with *Blossoms in the Dust*, staring Hollywood greats Greer Garson and Walter Pidgeon. The Strand remained open for twenty-two years, closing in October 1963. The Strand reopened again in January 1964. In 1970, the Strand once again closed. This time, the Strand Theatre would close its doors as a movie theater forever.

Spending Saturday evenings with western movie greats Roy Rogers, Gene Autry and Randolph Scott and the evening serials

about Superman, the Three Stooges and Buck Rogers was gone forever at the Strand.

For many years, the Strand stood lifeless, just a reminder of our past. In June 1982, the Swamp Fox Players bought the Strand. The organization's members immediately began renovating and restoring the original charm to the theater. After the restoration was complete, the Strand looked much like it did opening night in 1941.

The Strand was built by the Abrams brothers, with construction done by P.W. Munneke of Georgetown. The Strand had one screen and 546 seats.

It seems that over the years, some of the patrons have not wanted to leave the Strand. The presence of some unearthly visitors was noticed early on after renovations started. Sounds of these visitors' footsteps could be heard coming from areas where nobody was. Unexplained sounds came from the balcony and from behind the stage when nobody was there. The balcony was closed while the Swamp Fox Players concentrated on the main floor of the theater. When the balcony was opened, the sounds continued. The main two locations of the sounds were the balcony and backstage.

During a performance of *Ghost of the Coast*, the actors were portraying people from a long-ago era who died passionate or violent deaths. These deaths and the return of the dead have given Georgetown the title of "Ghost Capitol of the South." After the play (with one character named Doctor Buzzard) had completed, strange things began to happen. When one of the actors was leveling out the sand in a box that another actor had used during the play, cold air seemed to come up from the handprints. One of the actors turned off the air conditioner to see if that was the cause of the cold air, but the chill continued to come from the handprints in the sand. All the actors on stage felt it. One of the actors reported feeling a cold spot in one of the aisles. Several of the actors went and felt it. The air conditioner was still turned off, and the room elsewhere was getting warm.

The sound of people whispering also came from backstage. No one else was there except the actors, and they were all up front. One of the actors reported putting his hand against the background, and something pushed back against his hand.

There are no records of anyone dying in the Strand. Could the actors portraying the lives of people from the past have caused the spirits of the people to visit the theater? Read the complete story of Doctor Buzzard in *Legends and Lore of South Carolina*.

JOHNSONVILLE IMPACT CRATER

Meteorites are naturally occurring objects that originate in space, survive the fall through Earth's atmosphere and hit the ground or bodies of water. Most meteorites are remnants of asteroids or comets; however, a few have been pieces of the Moon or Mars. Many of these could have been traveling through space for thousands of years before visiting Earth.

Meteorites entering Earth's atmosphere are usually traveling between 25,000 and 160,000 miles per hour. At some point between 9 and 12 miles above the surface of the earth, the remains of the meteor will slow down to a point that the ablation (burning) process stops and there is no remaining visible light. At this point, its speed is between 4,500 and 9,000 miles per hour. Meteors continue to slow down until they impact the earth's surface. The size of the impact crater depends on the size of the meteorite when it hits the earth's surface.

Most geological processes slowly unfold over centuries or millennia. However, extraterrestrial objects impacting the earth traveling at two hundred to four hundred miles per hour will change the earth's surface in an instant. Most ancient impact craters have remained hidden. Some will probably never be discovered.

Johnsonville, South Carolina, is a quite peaceful little town. There are no tourist attractions to bring in multitudes of people. But it seems that Johnsonville just might have an unknown treasure. More than fifty meteorite impact craters have been identified in North America alone. The impact craters run from Alaska to Mexico. No impact craters had been discovered in the southeastern Atlantic states until the Johnsonville Impact Crater (JIC).

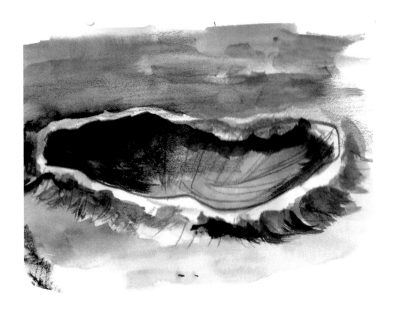

I have not been able to get a discovery date or impact date on the JIC. It was discovered due to gravity and aeromagnetic anomalies (deviations from common readings). These findings were supported by core samples. The impact crater is about eight miles wide. The crater is not well defined at the surface due to the amount of land and forest changes over the millions of years. The Johnsonville crater is a circular geophysical feature located at the junction of Lynches River and Great Pee Dee River. Snows Island is believed to be the upthrust of the center of the meteorite impact.

The gravity and aeromagnetic circular anomalies meet the geophysical criteria for those associated with buried complex impact craters. However, documentation of shock metamorphic textures provides the only real evidence for an impact crater.

In 1984, a bore hole was drilled in the suspected area by the South Carolina Department of Natural Resources and the United States Geological Survey. Results of the core samples prove that Johnsonville has an impact crater. Petrologic (regarding the origin, composition, structure and alteration of rocks) evidence of shock metamorphism (the solid-state recrystallization of preexisting rocks due to changes in physical and chemical conditions, primarily heat

and pressure) was found in the bore hole core samples similar to those found in already established impact rocks.

But that is not all the evidence. There is more still being uncovered. Within the magnetic low is a structure facing northwest–southeast and enclosed by two concentric moat-like lows. The pattern of the surface streams passing over the impact area is also consistent with a buried impact crater. Meteor craters are known to influence surface features. Drainage networks may extend radially from the rim of the crater. The map of the Great Pee Dee River shows thirteen curves just inside the impact area.

Most other circular anomalies in the South Carolina Coastal Plain (SCCP) consist of magnetic high signatures. The Johnsonville low magnetic signature was the only example of a feature with a coincident circular gravity and magnetic lows in the SCCP. This makes the Johnsonville low unique.

The bore hole used for this research is one of the few that have penetrated the basement underlying the wedge of sedimentary rocks in eastern South Carolina. The bore hole was originally drilled for ground water studies. This bore hole is on the outer rim of the impact crater at Brittons Neck. The core includes ten meters of Paleozoic crystalline piedmont basement. Impact breccias (rock consisting of broken fragments of rock cemented together by a fine-grained matrix—formed from regolith during subsequent impacts) were also found in this core.

Pradeep Talwani with the Department of Geological Sciences, University of South Carolina, sent the author this e-mail dated March 7, 2012, at 5:16 p.m.:

Dear Mr. Carmichael

Thank you for your interest in our work. We do not have any age constraints on the JIC. All we can say is it occurred less than 90 million years (Ma) ago. Whenever it did, it seems to have affected the drainage system.

Thanks,
Pradeep Talwani

Jack Smith, an avid outdoorsman, said that one day he was using his depth finder on his pontoon boat on the east side of the Great Pee Dee River bridge. His depth finder has a depth range of six hundred feet. He ran across an area in the river where the depth finder went blank—it could not pick up the bottom. The area it couldn't pick up was about thirty yards across. The average depth of the river around that area is eighteen to twenty feet deep.

An article in the March 7, 2012 issue of the *Weekly Observer* noted that the soil in that area is not conducive to bridge building. There are a lot of changes in condition in that site area, and because it is poor, you have to go pretty deep. The concrete sleeves used to anchor the bridge are sunk more than ninety feet in some places. This bridge is in the impact area.

THE VOICE

I met Noonie Stone when I was doing a book signing for *Legends and Lore of South Carolina* at the Johnsonville Library. There were several of us sitting around talking about personal experiences with the paranormal.

Noonie related a story that happened during her childhood in the Vox community near Johnsonville, South Carolina. Noonie was ten years old at the time of her experience. She was in the living room by herself watching TV just before nightfall. All of a sudden, out of nowhere, she heard an adult man call out, "Noonie." The voice sounded like it had come from the bedroom. It was not a voice that Noonie had heard before.

She knew that there was no man in the house and ran outside to the store beside the house, where her mother and father were. She asked if they had called her. Her mother told her that no one out there had called her. Noonie remained at the store until they went home for the night. This was Noonie's only experience with the voice.

This is the first known house built in that part of land. The house is about seventy-five years old. The original house was a two-room

home built by Noonie's aunt and uncle, who raised her. Noonie has lived there for sixty-three years. It has had two additions.

Noonie has been told by relatives that the house is built on an old Indian burial ground. Her father and brother have plowed up many Indian arrowheads while working the fields. Noonie still has one of the arrowheads.

THE HITCHHIKER

After my books *Forgotten Tales of South Carolina* and *Legends and Lore of South Carolina* were released, many people contacted me about their stories. I am always interested in hearing new stories and sometimes include them in upcoming books. I gather as many untold stories as possible, and I always take time at book signings if possible, so people can tell me their stories.

Angie Wilder Stone stopped by my house one day with her story; as she began, she had my undivided attention. When you pull onto a highway, you know where you're going, or at least you think you do. You never know what is waiting just around the next curve. As you travel down the road, you may spot a hitchhiker. You ponder whether to pick up this wayfaring stranger or just pass him by. The urge to help a stranger overpowers the need to continue on your pilgrimage. You stop, the stranger gets in and your world will never be the same. Just around the next curve, your

journey will begin with a trip into the past. This story begins with the death of Angie's father on Thanksgiving 1999.

Years later, it was a very cold, wet day at the end of November or the first of December when Angie was on the way to see a family member who lived near Lake City, South Carolina. She came upon a hitchhiker on the side of the road somewhere between 10:00 a.m. and 11:00 a.m. She was traveling on West Camp Branch Road at that time. Normally she doesn't stop for hitchhikers, but something was different here. She pulled over, and before he got into the car, she could smell the scent of wood burning in a stove. Her daddy always had a wood-burning stove in his house. When the hitchhiker got in, she didn't feel scared or uneasy at all. There was almost a feeling of a temperature change going down in the car. When Angie spoke to him, he said that

he had been down on his luck after he had lost his job. He just needed a ride up the road to the store. Angie said that she got a different feeling when he got into the car with her. She was very comfortable with him. She never looked at him directly in the face. It was like her daddy was in the car with her. They never passed another car or saw another person until they reached the store. The trip took about fifteen minutes. When they reached the store at the crossroads, she pulled in. Angie asked him what kind of work he did, and he said he was a welder and pipe fitter. That's what Angie's daddy had done all his life.

When he got out of the car, he knelt down and said to her, "I want you to know everything is going to be alright. I know you're a good person." Her daddy always knelt down like that when he had something important to say before he left. Angie said that she never got to tell her daddy goodbye. Angie felt like that was her daddy's way of talking to her.

When he walked inside, she left, picked up her cellphone and called her cousin to let her know where she was. She told her cousin about picking up this man, where she picked him up and where she had taken him. She said her cousin told her that nobody had lived in those trailers where she had picked the man up for years and that the store had been closed for maybe ten years. Angie said that when she pulled into the parking lot, it looked like a running store. There were even cars parked in the lot at the store.

Angie said that she has never seen this man again. She has asked around, and nobody knew him or has ever seen him. Angie still feels like that was her dad. Angie has been back by the store several times since then, and it's still closed. There's a house near the store where an older lady lives. One day, Angie stopped at the house and inquired about the man and the store. Nobody there knew what she was talking about, and the store was not running in 1999.

Angie said that she could still take you back to the place where she picked up the hitchhiker on the road. She can still tell you how it smelled and how he looked. "When I tell this story, my heart feels so full because I believe that was my last encounter with my daddy, and it was after his death." The store was called Norwoods Grocery when it was running.

THE ATKINSON HOUSE

Forgotten now after many years, the building is in total ruins. This onetime family home now stands as a grim reminder of the past. Overgrown with trees and weeds, the remains of this house stand hidden from view, with the last remnants of family life scattered across the broken floor and dust covering everything. The doors and windows are broken and boarded up, and it's been ten years since anyone visited what's left of what was once a happy home. The cheerful chatter of little children and the crackling of the fire are only memories of the past hidden between the walls.

When Cindy James introduced me to Mike Atkinson and I heard his story, I could almost hear the gunfire from Captain William McCottry and Major John James at the Battle of Lower Bridge. General Francis Marion and his men defeated the British near this location in 1781.

The historical marker on State Highway 377 in Salters, South Carolina, was erected in 1958. The marker is several hundred yards from the Atkinson House. It reads, "Battle of Lower Bridge." General Francis Marion and his men defeated the British at this place in March 1781. Advancing from the west and finding the bridge on fire, the enemy rushed the nearby ford, but here they were repulsed by troops led by Major John James and Captain William McCottry and were forced to abandon their plans to invade Williamsburg.

Following is the interview with Mike Atkinson. He is being interviewed by James Ebert for a video we were filming on the haunting at the Atkinson home.

Mike Atkinson and James Ebert are standing in front of the house.

Mike: "This is my house. It's an old family home. This house is about two hundred years old. Back in the Civil War, soldiers used to stay under a big oak tree out front. The soldiers used to stay under the house. It's been in our family for quite some years."

James: "I understand that you've had some unusual experiences here in this house."

Mike: "This took place in 1970 during the summer. It was when I was home by myself. I was twelve or thirteen years old. I was on

the front porch working on a mini bike, tightening the chain and changing the oil and stuff. My parents decided they would leave me here by myself. My mother had gone to her father's house, and my dad went uptown. My brothers and sisters were doing different things. I was on the porch by myself. I had gone through the house and locked all the doors. The only door that was open was the one behind me [the front door]. After a while, my dog sat down beside me. I heard the backdoor open 'cause it makes a squeaking noise when it opens, so I knew something was coming in the backdoor into the house. I just sat there. I was real scared. I heard it walking down the hallway on the hardwood floors like it had on heavy shoes, and it walked right up to the screen door behind me and pushed it open and come right out onto the porch. It was real hot until it got close to me. Then, all of a sudden, the air around me got freezing cold. I had a screwdriver in my hand, and I threw it at the door. The dog was barking and going crazy. All of a sudden, the door slammed back, and I heard it run through the house, slam the backdoor and run down the back steps. By then, the dog had run around the house and met it at the back steps and chased it across the field. Since then, other members of the family in the house have heard things in here. But you have to be here by yourself mostly at night. Prior to the time of this taping, I was cleaning up and standing here on the porch close to this window over here [the window on his left side]. I heard something fall in the house. It sounded like somebody had picked something up and dropped it on the floor. It hit with a loud noise."

James: "Can you take me and show me where this happened?"

Mike: "I'll take you down the hallway all the way to the back." They go inside the house.

Mike: "This is the entrance to the hallway where I heard it coming. It turned in here and opened that door [pointing to the front door]. There was a screen door that it pushed open. When it went back, I could hear it closing both these doors [pointing to the backdoor]." They walk around in the house.

Mike: "This is the first time I've been in here in ten years. [They walk into the kitchen.] This is the old kitchen. This house use to be a scary place at night. [Mike picks up an old briefcase

and looks through it.] I didn't know this briefcase was here. Well, nothing of interest in it. [Mike puts the briefcase back in the same place.] Well, so much for that." James is standing in the back of the kitchen.

James: "While I was standing here just a moment ago, looking out this window [pointing to the window at the end of the kitchen] at the porch to see what damage the elements had done and to see what else is left out there, I heard a noise, and it sounded like scratching on this wall [pointing to the inside wall near the window]. As I was about to say something—because I thought everyone had gone down the hallway back to the right over here—I turned around and looked, and everyone was in here in the kitchen with me. So, apparently, no one was down the hall, and there's nothing here that I can see that would have made any kind of noise." James and Mike leave the kitchen and go down the hallway.

James: "This is what would be on the other side of that wall in the kitchen. This is where the scratching had to come from. This is the bathroom, and again everyone was behind me in the kitchen. No, I can't explain it. Could it be the ghost of a Civil War soldier from the past? We'll never know." Mike is in living room.

Mike: "Most of the activity we've had with ghosts has been in the hallway. You can hear the person or whatever it is walking up and down the hallway. It'll walk right by you, and you won't see anything. When you hear it, the air around you feels real cold." We leave the inside of the house and are now standing in front of it.

James: "Can you tell us a little more about the history of the property?"

Mike: "This house was actually an army depot. They kept the weapons and stuff in the attic. The Confederate soldiers use to stay in the swamps around the house to hide from the enemy. We have a well in back that they used to drink water out of. They used to sleep under the house. There was a big oak tree out front that they used to stay under for shade in the hot summertime. A man that lived in Kingstree used to come out here and find guns, and he would take them to his school for show-and-tell days about history. While we were remodeling this house, we found a musket in the loft. My dad had it, but I don't know what he did with it."

James: "Can you take us around the house and show us the well? [They walk around the house to the well.] So this is the well that the soldiers would get water from!"

Mike: "They would take a rope and drop the bucket down into the well and pull it back up and drink water out of it. The well has always had water in it. This place has been here for about two hundred years. The well has always had good, fresh, cold drinking water in it." He goes on to tell us about finding bottles and coins and a few other things when they were planting their garden.

The Battle of Lower Bridge

General Francis Marion, along with forty of his men, and Captain William McCottry, along with thirty of his riflemen, successfully defended the Lower Bridge over Black River. They removed some of the planks from the bridge and set the eastern end of the bridge on fire. The British formed a frontal

assault on the ford. During the battle, McCottry's men killed the British captain who led the charge. The Americans lost five killed and eight wounded. The British lost twelve killed and wounded in the battle of Lower Bridge.

Captain William McCottry

William McCottry was born on March 2, 1748. He died on March 4, 1805. He married Mary White, and they were members of the Indiantown Presbyterian Church. McCottry was a member of the committee from Prince Fredrick's Parish to the Provincial Congress on June 3, 1775. He was appointed to the House of Representatives from Williamsburg (Prince Fredrick's Parish) in 1782. In 1788, he signed the petition for incorporation.

On March 5, 1754, he and his brother received a land grant of 300 acres. On March 20, 1770, William received another land grant, this time for 516 acres at the headwaters of Black

Mingo. On August 11, 1774, he received another land grant for 150 acres.

William McCottry was an Indiantown farmer. He and Mary had twelve children. William McCottry was laid to rest at the McCottry-McCutcheon Cemetery in Williamsburg County.

BLACK MINGO BAPTIST CHURCH

Black Mingo Baptist Church, located in Williamsburg County, is better known to the local people as "Old Belin Church." Black Mingo was built in 1843 by Cleland Belin using slave labor. Belin had the church built on part of his property.

By 1760, Charles Wood Mason had established a store at the head of Black Mingo Creek. By the early 1760s, Black Mingo settlement had developed on the creek. Black Mingo would later become known as Willtown. Soon after the settlement was well established, schooners carried local products to Charlestown. By 1804, the Black Mingo settlement had a tavern and twelve houses.

Cleland Belin came to Willtown as a boy and remained there the rest of his life. As an adult, Belin was a wealthy merchant. He later married Sarah Margaret McFadden. Cleland and Sarah McFadden Belin had thirteen children. Tragedy struck the Belin family, though: eleven of the children would die before the age of five. The two remaining children were Sarah Jane and Rebecca Ann.

Cleland Belin died on September 13, 1886. Due to the complexity of his will, it took twenty-five years after his death before his estate was settled. The will noted that trustees of the church may be elected by votes of the white members and could not at any time be controlled by the colored members.

Black Mingo Church was listed on the National Register of Historic Places on August 21, 1980. Black Mingo Church is a significant example of local interpretation of the Greek Revival style of architecture. The building was historically significant because of

its association with the development of the Baptist denomination in the Willtown area. Willtown, on the banks of Black Mingo Creek was a thriving port during the late eighteenth and early nineteenth centuries. The town had been completely abandoned by the early twentieth century. No reason was ever given for this.

The church cemetery surrounded the church and included the grave of its founder, Cleland Belin. Before it was burned, the church was the last surviving building associated with the nineteenth-century port of Willtown. By 1920, the congregation of Black Mingo Church had disbanded and the building abandoned. Later, the trustees of the Nesmith Baptist Church would assume the responsibility for the building. In 1992, vandals burned the church to the ground. They were arrested and sent to prison. Black Mingo Church was removed from the National Register of Historic Places on March 15, 2000.

Old Belin Church, as most of us knew it, had another history—a haunted history. Some people who had visited the church said that you could hear a choir singing in the building even though it had been abandoned since 1920. Another story that many people told was that you could see a shadow moving in the graveyard. Another says that you could see lights moving in the building.

I made many trips to the church in my teenage years, as well as a few trips later on in life. I visited during the daytime and nighttime. I only had one unusual experience. On one of my night visits, I thought I saw a light moving in the building, but only for the briefest of moments. I tried making a trip down to film the graveyard in July 2010, but the road was so torn up by log trucks that it was impossible to navigate.

THE HEMINGWAY LIBRARY

This section comes from an interview with Ann Van Emburg, a former employee of the Hemingway Library. The story that she related to me indicates that the library may be haunted by more than one spirit.

The story begins with Ann feeling a cold spot that she described as frigid, maybe twenty degrees different from the rest of the room. The location of the cold spot was in the children's corner. This is only the beginning of a very interesting story. As Ann continues, the Hemingway Library is beginning to sound like a hotbed of paranormal activity. Voices of children could be heard in the children's corner, followed by the laughter and the sounds of boys and girls running around and playing.

Shortly after that, books began falling of the shelves. Were the children still playing, or was there another spirit occupying the building? The laughter and sounds of the children have continued. No other people I have talked with report any strange sounds or sighting in the library. The only other account I could find was in *Ghosts of the Pee Dee* by Tally Johnson. There is no reason for the

library to be haunted since it's a fairly new building, unless something happened at that site in the past.

After exhaustive research and talking with many of the old-timers around town, I discovered that no one remembered anything happening in that area. I was able to trace the people who lived on that spot as far back as Dr. Ulmer, who lived there until he built his house between Hemingway and Stuckey. One person I spoke with believed that he may have seen patients in his home until he got his office built. That was as far back as anyone could remember. I could not find any record of any unusual happenings in that area.

Could this be a residual haunting? There is no set time for residual hauntings. It may be daily, nightly or yearly, but the same patterns are repeated. Nobody is sure if this is an actual haunting or just a window through time. Some speculate that it may be an opening to a parallel universe. Many researchers believe that residual hauntings are not really ghosts. Many investigators believe that the witness is actually seeing a recording of a past event that will play over and over again throughout time.

STONEWALL JACKSON HUGHES

Stonewall Jackson Hughes was born on February 22, 1862. The "Angel of Death" claimed Hughes on June 10, 1937. Stonewall Hughes married Sarah Martha Thompson on March 22, 1879. Sarah Thompson was born July 13, 1864. She passed away on September 21, 1932. She was laid to rest at the Ebenezer Methodist Church Cemetery. On June 15, 1937, Stonewall Jackson Hughes was laid to rest at the Ebenezer Methodist Church Cemetery.

In June 1937, late one evening, some friends and family were visiting with Hughes at his home in Muddy Creek, located between Hemingway and Johnsonville, South Carolina. Hughes told his guest to look over toward the church graveyard, which was across the road from his house. He said that the night before, he and Aunt Mattie were sitting on the porch talking. Back in the old days in the South, everybody sat on porches in the evening to catch the breeze. Hughes and Aunt Mattie saw a ball of fire come out of the graveyard and roll across the road and down their lane. It continued onto the porch, rolling beside them and on into the house. He told them that it meant that someone was going to die. Stonewall Jackson Hughes died on June 10. Was the ball of fire a messenger of death? After the services, as the hearse was taking his body to the graveyard, it traveled the same path the fireball had.

AGNES OF GLASGOW'S HAUNTED GRAVE

Perhaps a ghost or spirit that continuously makes appearances is some kind of energy form that can travel through time and space. Perhaps this energy form can make an appearance at the desired time and place. Some of South Carolina's ghosts have been around for hundreds of years. Do these wandering spirits have a place to stay and just make periodical visits to the real world?

South Carolina graveyards seem to be hotspots for the return of ghostly apparitions. South Carolina has no shortage of haunted graveyards. Camden has one of the most famous haunted graveyards in the Palmetto State. For more than 225 years, a beautiful young woman has been wandering around the old Quaker graveyard in Camden. Agnes of Glasgow is still searching for her lover. Agnes, born in Scotland (1760–1780), followed her lover, Lieutenant Angus McPherson, to America. McPherson was a British soldier who came to America to fight for the British.

Agnes stowed away on a ship bound for Charleston, South Carolina. She arrived there believing that her lover was stationed in Camden, South Carolina. Agnes wandered aimlessly through small settlements and woods until she finally arrived in Camden. Her arrival was met with distressing news: no one there knew McPherson or where he might be stationed.

Agnes became ill and died before she could be reunited with him. She was buried under the cloak of darkness by Wateree American Indian King Haigler.

The legend of Agnes of Glasgow is that she still haunts the old Quaker cemetery and the surrounding woods. Another legend is that she still roams the streets of Camden and the area where

the British soldiers were camped. This story has received media attention in South Carolina, as well as from local ghost hunters and ghost hunters from around the country.

EAST

USS HARVEST MOON

The USS *Harvest Moon* was originally the civilian steamship *Harvest Moon*, built for commercial use. It was a 546-ton side-wheel steamship built in Portland, Maine, in 1862. The *Harvest Moon* was bought by the navy in November 1863. The ship was commissioned as the USS *Harvest Moon* in February 1864.

The ship was to join the South Atlantic Blockading Squadron, which operated along the coast of South Carolina, Florida and Georgia. The squadron's commander, Admiral John A. Dahlgren, made the USS *Harvest Moon* his flagship.

On March 1, 1865, while on patrol in Winyah Bay near Georgetown, South Carolina, with Admiral John A. Dahlgren on board, the USS *Harvest Moon* hit a Confederate mine and sank. The explosion from the mine tore open the bottom of the ship, and it sank within minutes. There were two men left on board when the ship sank, wardroom steward John Hazzard and a young black man.

The black man was a slave who had been allowed to stowaway on the ship.

The ship sank about 4.6 nautical miles from the clock tower in Georgetown, South Carolina. The ship was subsequently abandoned where it sank. The *Harvest Moon* still rests where it went down more than one hundred years ago. Now most of it is buried beneath the shifting sands of Winyah Bay. Its smokestacks still stand out, proudly visible to boaters out on the bay.

The crew on board the USS *Harvest Moon* included Admiral John A. Dahlgren; John Crosby, commanding; ensigns David Arey, A.N. Bates, William Bullis and Lewis Cornthwaite; Assistant Surgeon Asahel Dean; Assistant Pay Master Samuel Thomas Jr.; Second Assistant Engineer James Miller; Third Assistant Engineers Henry Ficher, Fredrick Racoe and William Todd; pilots William Uptergrove and W.S. Nany; and ninety-five other crew members.

The ship's builder was Joseph W. Dyer of Portland, Maine. The *Harvest Moon* was launched on November 22, 1862. The owner of the ship was Spear, Lang and Delano of Boston.

The navy's acquisition was on November 16, 1863, in Boston by Commodore J.B. Montgomery at a cost of $99,300.

The ship was 193 feet long. The beam was 29 feet long, and the depth of the hold was 10 feet, with an 8-foot draft. The average speed was nine knots, with a maximum speed of fifteen knots. The ship carried one twenty-pounder Parrott rifle, four twenty-four-pounder Howitzers and one twelve-pounder rifle.

The engine had been salvaged from a steamer that was lost in Chinese waters. It was shipped to Halifax and rebuilt by the Portland Company as engine no. 4.

The only person listed in the official report as being lost in the sinking of the USS *Harvest Moon* was John Hazzard. The slave was never listed as missing because he was a stowaway on a Federal ship, and his family was afraid of what might happen to them. Because Hazzard's body was never recovered and given a Christian burial, many locals believe that the boy's spirit still haunts the site of the USS *Harvest Moon*. Some fishermen and locals have reported hearing moans coming from the shipwreck area.

THE EXCHANGE PLANTATION

The Exchange Plantation is located on the Pee Dee River in an unincorporated community in Plantersville in the Prince George Winyaw Parish of Georgetown County, South Carolina. The earliest known existence of the Exchange Plantation is 1822. The plantation is currently privately owned. The community became known as the Exchange Plantation because the owner received it in exchange for another piece of land. At one time, it was known as the Asylum Plantation.

The plantation includes 1,400 acres. The primary crop was rice. Rose Bank Plantation was incorporated into the Exchange Plantation. The original house is still standing, but another part has been added. The part added was as large as the original house. The owners throughout the house's history have been as follows:

- 1825: Elizabeth C. Ford, Cleland Huger, James Lewis, LaBruce Lachicotte and Davidson McDowell
- 1837: Guendalos Rice, Thomas G. Samworth and Francis Weston
- 1843: Benjamin and Charles Allston
- 1853: Robert F.W. Allston

- 1864: Elizabeth Waites
- 1869: Benjamin and Charleston Waites
- 1945: Moore, Pringle and Mrs. Thomas S. Ragsdale
- 2004: Mrs. Thomas S. Ragsdale

The Exchange Plantation is haunted by the ghost of a slave woman who was denied her supper for coming in from the rice fields too late. The overseer kicked over the pot of food so the woman wouldn't have any. The woman swore that the plantation would never be owned by one owner for very long. The ghost of the old slave woman appears occasionally to help around the plantation. At times, you can hear the ghost walking up the stairs in the old house, and you sometimes feel her touch you on the shoulder while you sleep.

OLD GUNN CHURCH

Prince George Parish was founded in 1721. In 1734, Prince George Parish was split into two different parishes, Prince George Parish and Prince Frederick Parish.

In 1859, work began on Prince Fredrick Episcopal Church. Later, it would become known as Old Gunn Church. Old Gunn Church is located on Plantersville road in Plantersville, South Carolina. In 1860, work on Prince Fredrick Episcopal Church came to a sudden halt. During the Civil War, construction had to stop because of a shortage of money. When Thomas Gunn, the architect of the church, got word of this, he went to the church bell tower to put some finishing touches on it before they stopped.

When Gunn began to climb down, he lost his footing and plunged to his eternal calling. Gunn, cursing as he fell to the ground, did not die instantly. He lay there, cursing and ordering the workers to help him. Gunn had been so mean to his workers that they just stood there and watched him die. Many believed that the church itself was cursed because Gunn cursed as he fell to his death.

After the Civil War ended, the builders restarted work on the church and continued until it was finished. The church was active for about fifty years. One night, the church mysteriously caught fire and burned to the ground. The congregation never rebuilt the church. Today, only the bell tower remains. The remains are on private property, and there is no trespassing allowed. Was Prince Frederick Episcopal Church cursed from the beginning by Thomas Gunn?

Some who have visited the ruins say that if you stand across the road on a moonlit night, you can see Thomas Gunn working on the bell tower and falling to the ground. Some say that if you stand

near the bell tower between sundown and dark, you can hear the heavenly voices of the choir chanting out their favorite hymns. Others report seeing lights in the top of the bell tower. Some believe it's Thomas Gunn still working on the church. I have visited the remains many times, and only once have I heard the faint sound of the heavenly choir singing.

Many years ago, a forest fire burned through that area while I was visiting the remains. As I watched, the fire burned up to the fence and stopped. Not one spark came inside the fence. Was someone or something protecting the remains of the church and the old graveyard nearby?

MORGANNA

Streets are lined with moss-covered oak trees, most of them more than one hundred years old. Many historic buildings stand along the way. Tour guides tell their stories of the historic port city. Tales of wealthy rice plantation owners, slavery and the seafaring people and their way of life bring people from all across the nation to take a tour of the historic port city of Georgetown, South Carolina.

However, these are not the only tours you can get in Georgetown. When darkness slowly creeps in, the more adventurous can get a ghost tour. If you are such a person and like to live on the edge, then a ghost tour is just what you need. These very knowledgeable guides will take you around the city, showing you the haunted locations of which Georgetown is proud.

Many visitors to Georgetown don't know that a ghost is lurking around every corner. The ghostly apparitions have become part of the community, and the residents of Georgetown have learned to live with these unearthly visitors.

Barbara Bush is one of the many residents who share a house with a ghost. She calls her resident ghost "Morganna." I heard about Barbara's ghost and called to see if I could get an interview for a story for my next book. She had read my first book, *Forgotten*

Tales of South Carolina, and graciously invited me over. James Ebert and I arrived at Barbara's house a few minutes before the appointed time. Her home was a two-story house built in 1903. The house was well kept, with greenery around it and ivy covering most of the steps. As we stepped up on the porch and knocked on the door, our host opened the door and welcomed us in. She gave us a tour of the bottom floor, lined with antiques and old pictures that adorned the walls. Many of her own paintings decorated the walls in the rooms that she showed us.

She led us into the sitting room and closed the old-fashioned door between the parlor and sitting room. She told us to have a seat. James sat near the door, while I set up my recorder. I didn't want to miss a word of this story. I sat across the room from her as she began to tell her story.

She and her husband bought the house in 1993 when they moved to Georgetown from Fort Worth, Texas. Barbara and her husband didn't know that the house was haunted when they moved in. The previous tenants didn't tell them, so it was a complete surprise. Barbara said that she would have bought the house anyway. She said she was not afraid of spooks.

There were several instances that made them realize that there was indeed a ghost in the house. They just accepted that they had a ghost as a guest in the house. Barbara named her after King Arthur's evil half-sister, Morgan le Fay.

Morganna's biggest trick is to take things and hide them for about six months. She always brings them back. Barbara said that she can't tell how many things have disappeared and reappeared over the years. It started out one morning with her husband when he got up. He had a big chest of drawers in which he kept his clothes. He pulled open the drawer where he kept his underwear. He called down to Barbara and asked her what happen to his jockey shorts. He said the drawer was empty. Barbara told him that she had washed yesterday and that the drawer should be full. This was the first incident of things disappearing. Barbara went down to the store and got him some new ones. She bought six more. About six months later, Morganna brought all the old ones back. He got up one morning, and there they were. Things started

disappearing about a month after they moved in. Barbara can't remember the month.

The next incident was with her husband's tobacco jar. It was glass covered with leather and had been in the family for years. He kept it sitting by his chair, and in the morning, when he came down, he would sit down and have a smoke with his coffee. One morning, he noticed that the tobacco jar was missing. He asked Barbara what she had done with his tobacco jar. She told him that she hadn't done anything with it. Morganna must have gotten it. About six months later, he came down one morning, and the tobacco jar had been returned.

Later, Barbara found out that the people who had rented the house before had also had a ghostly experience. One person was a schoolteacher who always left her car keys in the same place every time. She came down one morning, and the keys were gone. She searched for them but couldn't find them anywhere. She had to use her spare key. She came home that evening after work and was straightening up the bed and found the keys under her pillow. She told Barbara this story long after they had bought the house and moved in.

There's a little closet upstairs with a snap lock on it that can only be locked from the outside. The teacher came home one evening and couldn't find her cat. She kept hearing it meow but couldn't find him. She finally found the cat locked in the closet. She just accepted the fact that the ghost was there.

Barbara said that Morganna does talk to her over the phone but not in a voice. Barbara came home one day after a trip to Texas to visit her children. She had had a terrible trip—she missed the plane, and they lost her luggage. That trip was one of those horror stories. She came in and plopped down in the chair and asked Morganna if she missed her. The phone beeped four times. That was Morganna telling Barbara that she missed her.

It doesn't bother Barbara that people think she is a little weird. Barbara said that she guessed it was because they never lived with a ghost before. Barbara said that she's not afraid of ghosts. She is more afraid of the living than the dead. There's a lot of bad stuff out there, and she's more afraid of that than of a ghost.

One day, Barbara fell and was hospitalized for several days. When she returned home, they had her on a lot of medication. One morning, her friend came over to help her with her medicine and noticed that a bottle was missing. All her medicine was kept on top of the dresser. It disappeared for about three weeks and was returned to the same place.

Barbara is not sure if any of her animals see Morganna or not. She keeps seeing her dog looking up the stairs like she sees something. Barbara said that she don't know who Morganna is, where she came from or why she is staying there. Barbara has a list of everyone who has lived in the house, and one day is going to read the names and see if Morganna will give her a sign. She said that she has never heard any sounds, smelled any perfume or felt anything.

We were sitting there talking with Barbara when she said, "Morganna, if you want to talk to these two gentlemen, just beep the phone." There was no beep on the phone. It was 11:15 a.m. when she asked Morganna about talking with us. The phone didn't beep, but several minutes later, the door between the parlor and sitting room opened about halfway, just as if someone had walked into the room. It did not close back.

Barbara said that there's a theory that when Georgetown was 90 percent black, with many slaves, the slaves brought over their voodoo. If you notice, many of the old homes in the historic district have their ceilings painted light blue. That's called haint blue. It's supposed to keep the haints out, but it didn't keep Morganna out.

Barbara is an artist, and the only time she's felt a presence in the house was when she was painting a portrait of her father. She was having trouble getting his features right because she was painting from a picture. She felt something brush against her shoulder. She believes it was her father helping her get the portrait right.

After the interview was over, we walked into the parlor, and I tried the door. Once the door is closed, it latches. The doorknob has to be turned to open it. The door will not move on its own. There were no doors or windows open, and the air conditioner was not on. There was no way for a draft to open the door.

Haunted homes are located throughout the United States and the world. Many people today can tell you of personal stories of various

types of ghost sounds, visual phenomena, other unusual sounds and strange electrical activity (such as lamps turning on by themselves).

More people are opening up today about these unexplained activities. In the past, they feared ridicule, losing their jobs or even being put away because society thought they were crazy. One-third of the people in the United States believe in haunted houses. Most of them believe that they have lived in one or have visited one.

LORIS HAUNTED HOUSE

The names and exact location have been left out of this story. I could not locate much information on this.

When the father of a Loris, South Carolina family died, the rest of the family honored his wish and had him cremated. Later, the mother passed away and was also cremated. They held on to the ashes of the dear departed, not wanting to bury them yet because they weren't sure if they were going to move or remain on the family homestead. Later on, a roommate moved in.

Unusual things began to happen then. The stereo would turn on by itself. The roommate blamed the other person for turning it on. One day, the roommate came home from work and found the stereo on. He immediately turned it off. When the owner walked in, the stereo turned itself on again.

The old mobile home was traded in for a newer model and placed on the same location on the property. Since they decided not to move, the parents were given a Christian burial. The unexplained things stopped happening.

Shortly after the sister died, footsteps could be heard walking the length of the home. This continued back and forth, over and over. This would only happen when the other person was in bed. The footsteps would stop when the person in bed shouted, "I'm trying to sleep!"

Since then, things got even stranger. Apparitions of a man and a woman have been seen inside the house. The apparitions always

walk from a southwest direction to a northeast direction. They were so clear that you could see their arms swinging. Knocks on the walls and doors were frequently heard. Heavy thudding sounds were also heard. This always happened between 2:00 a.m. and 4:00 a.m. At times, you could smell the faint odor of baking food in the kitchen even though nothing was being baked.

It seems that the restless spirits have calmed down now and are letting the owner live in peace.

THE NEUTERCANE

This story is a little unusual because it happened about twenty miles out to sea from North Myrtle Beach, South Carolina. It involves a "neutercane," an airplane, three people and the roughest forty-five minutes of a lifetime.

I've never heard a neutercane mentioned on any weather broadcast. Apparently, not many meteorologists, if any, know about it or just don't care to mention it. Some say that the neutercane doesn't exist. Many pilots disagree with that, especially if they've been caught in one. A neutercane is a freak storm of violent intensity that covers a small area. It does not show up on weather maps because it happens too fast and disappears even faster. When they appear, they can tear apart the ocean's surface, causing waves to reach twenty feet high or higher. Some waves have reached more than fifty feet high. These can spawn waterspouts at an unbelievable rate.

Many people believe that the neutercane is responsible for many disappearances in the Bermuda Triangle and the Great Lakes, though there's no proof of that one way or the other.

This incident happened on December 31, 1968. Three people were on board a specially built Apache airplane flying from New York to Florida. When they left New York, it was bitterly cold, with scattered snowstorms. Flying through treacherous weather, at one point they reached about twenty miles from the coastline at North

Myrtle Beach, South Carolina. The pilot contacted Myrtle Beach radio for a weather report—cold, with gusty winds and visibility at seven miles.

They were flying at two thousand feet when it happened. The sky changed from broken clouds to a glazed, glasslike white. They knew they were in trouble. At that very moment, radio contact from the plane to the North Myrtle Beach FFA station went dead. The navigation system in the plane went crazy. Things were about to get really bad. They saw a strange line from one end of the horizon to the other end. It looked like a wheat field, with wheat bending down in a summer storm.

The sky had now become a brilliant milky white. The surface was unbelievable. What they thought resembled a wheat field turned out to be pine trees bending in the wind. They were now facing a terrifying wind with blinding snow and zero visibility behind them. They couldn't turn back. There was no place to go except straight into whatever it was meeting them. This was not the Bermuda Triangle; it was the Atlantic Ocean off the coast of South Carolina.

Now they were facing some real danger and electrostatic charges. The electricity in the air was making their clothes stick to their skin. The female passenger's hair stood on end. There were blue sparkling flames popping out everywhere. It was St. Elmo's fire at its finest—a weather phenomenon in which luminous plasma is created by a coronal discharge from a sharp or pointed object in a strong electric field in the atmosphere (such as those generated by thunderstorms).

The pilot lost control of the plane when the shock wave of air from the neutercane hit the plane. There was no place to land and no control of the plane. The plane would lose altitude and then go straight up. The weather had control of the plane. The pilot and passengers were being thrown about the plane despite the harnesses. Now things started to get even worse. The glass on the gages began to crack. Then, all of a sudden, the rear window cracked. The antennas were breaking off the plane. All radio contact was lost.

The pilot had no control over the plane. It was being thrown forward, backward, sideways and up and down. Nothing the pilot could do made any difference. There was a second of relief, and then the plane was thrown up into an invisible wall and knocked

back down. The pilot, thinking that nothing else could happen, looked up and saw just ahead a line of seven waterspouts. They made it through the waterspouts, but not without some damage. The female passenger hit her head on the side of the plane, producing a big gash.

The plane came tumbling end over end over North Myrtle Beach. The pilot almost had the plane on the runway when they were snatched from the hands of safety and thrown back up about seven hundred feet.

Finally, after what seemed like forever, the plane was about to touch down. Ten seconds after landing, the storm vanished as quickly as it had come. It took them forty-five minutes to fly twenty miles. The storm did about $6 million worth of damage to North Myrtle Beach, South Carolina.

The name of the pilot is withheld because the people in the corporate offices don't like pilots reporting anything unusual. At the time this happened, he was flying his private plane, but he is employed as a commercial pilot.

AUNT SISSY

A cracked and faded portrait of a little girl stately hangs at the top of the stairs in David Bennett's Myrtle Beach townhouse. The original gold and brown frame encases the portrait of a lovely young girl. What seems to be an innocent portrait is actually anything but. The portrait seems to be the only remains of this young girl, or is it? The young girl in the portrait is David Bennett's great-great-aunt Nancy Elizabeth Hickman, better known to everyone as "Aunt Sissy."

Nancy Elizabeth Hickman was born on a little community plantation in North Carolina known as Hickman Branch. It was just across the state line. She died in 1878 of a fever—depending on who's telling the story, it was either scarlet fever or some other kind. According to family stories, just before Sissy died, she would scream for her mother, which was David Bennett's great-great-

grandmother Nancy Marlow Hickman. Sissy did not recognize her own mother when she went in to check on Sissy.

Sissy died in 1878 and was buried in the Hickman family plot in Hickman Branch. About that time, the picture appeared among the family's possessions. No one really knows where the picture came from. Some speculation is that a traveling photographer may have taken it.

The picture stayed in the family and was passed on down. After the great-great-grandmother passed away, the picture was passed on to great-grandmother Iretta Hickman, long known to many as "Rhett." It was about that time that strange things began to occur around the picture. The going joke among the family was that "it was Aunt Sissy that did it." The phrase "a Sissy moment" was coined.

When great-grandmother Iretta Hickman went to her final reward in 1966, the picture was passed on to Bennett's grandmother, Bula Bennett. The picture hung in her dining room for many years without any "Sissy moments."

David Bennett's uncle built a home in Wilmington, North Carolina, and in need of some family pictures to go by the staircase, the picture was given to him. Aunt Sissy's picture hung in his home for many years. In 1986 or 1987, David Bennett's grandmother got the picture and passed it on down to David.

The picture stayed in storage in Bennett's parents' home until 1995, when Bennett graduated from college and got his first job, moving to Myrtle Beach, South Carolina. Nothing unusual happened during the time the picture was in storage. When Bennett moved to Myrtle Beach, he brought the picture with him. After trying to find an appropriate place to hang Aunt Sissy's picture, he decided to just pack it away. Bennett said jokingly to Aunt Sissy, "I'm going to have to pack you away. I can't find a place for you." Bennett placed the picture on the floor, leaning against the wall, and retired for the night.

Later that night, Bennett was suddenly awakened by what felt like someone or something hitting him on the arm. Just as he turned over to see who it was, he saw the faint glimpse of a blur going out of the room. Bennett got up and looked around. All the doors and windows were closed and locked. He returned to bed, believing that he had had a dream.

The following morning, when Bennett was dressing for work, he noticed a bruise on his arm where he thought something had hit him. On the way out, he noticed Aunt Sissy's picture still leaning against the wall. He looked at the picture and thought that it must have been a "Sissy moment." When he returned home from work that evening, his first job was to find a place to hang Aunt Sissy's picture. Bennett found a prominent place for the picture, and no other major incidents happened during the next five years.

There were, though, a few little things that happened. One morning, as Bennett was preparing his lunch for the day, he heard a *click*, looked around and saw his bedroom door opening. Bennett said, "Stop it, Sissy," and the door stopped. The door could not be opened unless the doorknob was turned.

Another minor incident happened with Aunt Sissy when one of Bennett's friends came to Myrtle Beach for a job interview. The friend stayed with Bennett while he was in town and slept on the couch. When Bennett was leaving for work one morning, the friend asked him to turn on the television on his way out.

When Bennett returned home that evening, he was met by his friend and told that he was not coming back to his place. His friend told him that when he woke up again, the television was turned off, and there was a buzzing sound coming from the bathroom. When his friend investigated the sound, he found that the electric razor was on and moving around on the sink, but it would not fall off. He turned the razor off. He told Bennett that he was leaving and that the picture freaked him out.

The next few years were uneventful, until Bennett started to move into his present townhouse. Bennett had ten people helping him move. They had three trucks and had set up an assembly line for moving the items out. Bennett had given them instructions to leave all the pictures there—he would go back and get them. By late that evening, they had everything out and were making the last trip. Bennett was standing on the steps of the townhouse when all three trucks and several cars pulled up. Everybody got out in a hurry. One of his friends told him that there had been a "Sissy moment." Two got out of the car and told him that they'd never go back there again. They told him that one of them had jokingly told Sissy that Bennett didn't want her anymore and that she would have to stay in the dark. At that time, the kitchen light came on. Sissy was letting them know that she didn't have to stay in the dark.

The picture of Aunt Sissy now hangs prominently at the top of the stairs in David Bennett's townhouse. After he moved into the new townhouse, there were only a few little Aunt Sissy moments. One morning, as Bennett was preparing to go to work, he heard his cat's toy rattling around. When he looked around, he saw the cat sitting at his feet. While he was returning from taking out the trash, he heard the toy again.

One of his next-door neighbors told him that he had seen a little girl in his townhouse who looked and was dressed like the girl in the picture he had hanging at the top of the stairs.

Author's note: While I was filming an interview with David Bennett, about halfway through I felt something brush against my back. I looked around for anything, maybe an air conditioner vent, that could have made that feeling against my back. There was no vent or anything else in the area.

After filming the Aunt Sissy interview, I was going to film a short segment about the silver that had been handed down to David Bennett. He had the silver set up on the dining room table: two candelabras, a cake plate and two cake servers. Bennett backed away about six feet from the table. Video host James Ebert was about six to eight feet from the table. I was setting the camera up about eight feet from the table when part of one of the candelabras hopped right off and fell on the table. Bennett replaced the part and returned to his original position. The same piece hopped off again. Ebert said, "This must be a 'Sissy moment.'" The filming went on without anything else happening.

LOWER RIVER WAREHOUSE

The Burroughs Company Lower River Warehouse was built in 1880 on the Waccamaw River. It was used as a terminal for the Waccamaw line of steamers operated by the Burroughs and Collins Company. The steamers ran until 1919. The warehouse then sat vacant for about forty years. It has been converted into a meetinghouse but has retained the interior and exterior appearance. The Lower River Warehouse is located in Conway, South Carolina.

The warehouse is used once a year by Luke Anderson for his Halloween haunted house Terror Under the Bridge. Anderson has been running the haunted house since 2005. Most of the proceeds are donated to charity.

Anderson said that there were some strange things going on in the warehouse that he can't explain. When Anderson and his partner Gene are working alone in the warehouse preparing for the haunted house and one leaves, shortly afterward the remaining man can hear footsteps or other unexplained sounds. He can hear the footsteps so clearly that he thinks the other person has returned. When he call out to him, there's no one there. There are several areas in the

warehouse in which the actors for Terror Under the Bridge refuse to
work. The back end of the warehouse is where they set up the fog
machines. Anderson was in the area with the fog machines one year,
and another actor was in another area nearby. They used mirrors
for contact so they wouldn't have to talk to each other.

One night, the actor in the other area kept getting more and more
frightened. He wouldn't go into the room with the fog machines.
When Anderson asked him what was wrong, he told Anderson to
look at the fog. A door and window were open on the end with the
fog machines. They were using the draft from the open door and
window to blow the fog back into the rest of the building. The fog
should have been going back into the building, but it was moving
against the draft. It was moving toward the open door and window.
Those were the only two openings in the building, so there were no
other drafts to blow the fog backward.

A lot of actors have felt cold spots in another room. The longer they stay in that room, the colder it gets. James Ebert was there when I interviewed Luke Anderson. Ebert reported seeing something moving from left to right on the outside of the end window. When you look outside the window, there is about a fifteen-foot drop with water under it. Anderson pointed out another area in the building on the other side of a wall where the sound of a hammer or some other heavy object has been heard falling to the floor. When someone goes to check it out, there's nothing there.

We arrived at the Lower River Warehouse at about 7:10 p.m. The first thing I did was set up a digital sound recorder in the loft. It was left on to record the entire time we were there. I played the recordings back on the way home, which is about an hour's drive. The only unusual sounds on the recording were footsteps moving around in the loft.

SOUTH

SEASIDE PLANTATION

The Seaside Plantation is located in a rural setting on Edisto Island, South Carolina. The earliest known date of its existence is 1790. In 1795, the Fripp family built the main house. In 1802, Seaside cotton planter William Edings bought the property. At that time, the Edingses were a prominent family of Edisto planters.

Edings's son, also William, was a member of the state legislature from 1856 until 1857. Due to his popularity, Williams Edings was reelected in 1858 for another term but met with a untimely death before he could take his seat.

I couldn't find a record of what happened to the 1795 house or if the Edingses just decided to build another house. The two-and-a-half-story home's style and structure are evidence that it was built in about 1810. The home is significant as an example of the Federal-style architectural structure similar to the Charleston single house plans. The interior features Federal decoration on the mantelpiece, chair rails and ceiling moldings.

In 1865, Seaside Plantation became a center of activity for the Port Royal Experiment. This was a program designed by the United States government to train and educate the newly released slaves on the Sea Islands.

The only place I could find the following information was a small blip on the Internet. Like all southern plantations, Seaside Plantation would not be complete without its share of tragedies. Locksley Hall became known as the "House of Tragedy." Two young Edings children died of diphtheria there. One of the owners (no name given) cut his own throat and bled to death. Nothing will cover up the bloodstains on the floor, no matter how much work they do to that area. There are reports that at night you can still hear the blood dripping to the floor. Another story associated with the Edings family notes that a close relative of the Edingses was left orphaned and went to live on Seaside Plantation. At age seventeen, he returned home from a hunting trip and went upstairs to put his gun away. He met his momma (the lady who had been with him since he was born) and handed her the gun. It accidentally went off, killing the lady. In shock over the death of his momma, he picked up the gun and killed himself.

THE HAUNTED BAYNARD CRYPT

In 1774, John Stoney (Captain Jack) and his wife arrived in South Carolina from Ireland. He came over in his own boat, the *Saucy Jack*. John Stoney was engaged in the war for independence as a privateer. During the next two years, Stoney acquired a fortune, and in 1776, he bought the one-thousand-acre Braddock Point Plantation.

In 1793, with the help of slave laborers, Stoney began to build his home on Braddock Point Plantation. The house was forty feet by forty-six feet, with a large front porch designed for entertaining. Stoney is also noted for his part, along with Isaac Fripp, in the founding of the Zion Chapel of Ease in 1788.

Stoney was killed in a hunting accident in 1821 and was laid to rest on the spot where he fell near Fish Haul Creek, which is on the

opposite end of the island from his home. In 1959, Stoney's remains were reburied at the Zion Cemetery.

In 1840, William Baynard purchased the one-thousand-acre Braddock Point Plantation from the Charleston Bank. Baynard already owned Spanish Wells and Muddy Creek Plantations on Hilton Head. He raised the highly profitable Sea Island cotton on his plantations. Baynard produced thirty-six bales of cotton, one thousand bushels of corn, five hundred bushels of peas, one thousand bushels of sweet potatoes and 350 pounds of butter.

William Baynard moved from Edisto Island to Hilton Head, and in 1845, he constructed a mausoleum in Zion Cemetery. He died in 1849 at the age of forty-nine, four years after he completed the mausoleum. He was laid to rest in the mausoleum and was joined by his wife five years later. The vast Baynard holdings were inherited by Ephram, William's son. Ephram managed the Baynard estate until 1861.

When the Union army occupied the island in November 1861, most of the landowners left the island. Federal forces used the Braddock Point mansion as quarters as late as 1864. After the use by Federal forces, the mansion was subsequently burned.

The only thing left of the mansion is the foundation and a corner wall. There are some foundations left of several of the outbuildings. The mausoleum is the oldest remaining intact building on Hilton Head. The tomb is empty.

Now to the ghost story about the haunted Baynard crypt and a warning to all those who desecrate the dead. Years after the Civil War, grave robbers tried to break into the mausoleum. One was killed by a tile that fell from the ceiling. Another got inside the mausoleum, and the door closed behind him, locking him in. Unable to get out, the grave robber died in the mausoleum. When the door was opened by another grave robber on another night, the corpse fell on top of him. The scare was so bad that it gave him a heart attack, and he expired. A group of teenagers approached the mausoleum, only to see a man and woman in period clothes standing near the door. As the teens neared the door, the couple vanished.

THE OLD SHELDON CHURCH

The red brick ruins of Sheldon Church still stand like ghostly columns out of the past—a grim reminder of what happened in South Carolina's history. The ruins of Sheldon Church are located between Yamassee and Beaufort, South Carolina, just off Highway 17 on Old Sheldon Church Road.

Old Sheldon Church was originally known as Prince William's Parish Church. The land on which the church was built was donated by wealthy plantation owner William Bull. His plantation bordered the land for the church. Much of the funding was provided by Bull as well.

In 1751, the cornerstone of Prince William's Parish Church was laid. Work continued on the church, and in 1755, Prince William's Parish Church was finally completed. The first church services were held shortly after. The Prince William's Parish Church represented the first temple-form neoclassical structure in America. The structure helped to initiate the Greek Revival style in the South.

Unfortunately, the church's benefactor, William Bull, died before the completion of the church. William Bull was buried inside the church at the base of the altar. The original stone making his grave is still in place. The original church was adorned with an equestrian statue of Prince William. The statue was placed under the porch, which was supported by four freestanding Doric columns.

As many wealthy families moved into the area around Prince William's Parish Church, they began to use the church on a regular basis. As the Revolutionary War beckoned, life in South Carolina's Lowcountry changed. In June 1775, thousands of pounds of gunpowder were captured from the British ship *Little Carpenter*. The gunpowder along with other items was stored in Prince William's Parish Church. This was a mistake and would lead to the destruction of the church.

In May 1779, the church was destroyed by British major DeVeaux—leaving not just the church but also the Bull family estate

(Sheldon Plantation) in ruins. The church was rebuilt in 1826 and given the name of Sheldon Church of Prince William's Parish.

On January 14, 1865, General Sherman's Fifteenth Corps under General John Logan burned Sheldon Church. This was considered part of Sherman's March to the Sea as he crossed South Carolina from Savannah, Georgia. The church was never rebuilt.

The columns of Sheldon Church still remain standing today as a ghostly reminder of what historical places had to endure during the violent past in South Carolina's history. The Bull family were originally buried in above-ground vaults on the Bull family property but have since been removed due to vandals trying to open them.

St Helena's Episcopal Church now own the ruins. On one of my visits to Beaufort, I took a few minutes out to visit the ruins. If you're in the area, stop by. It's worth your time.

SOUTHEAST

THE GHOST OF LAVINIA FISHER

Lavinia Fisher was born in 1792 or 1793; it's unknown if she was born in Charleston, South Carolina, or somewhere else. The story of Lavinia Fisher has been retold so many times that it's hard to tell which parts are fact or fiction. The story of Lavinia's life leading up to her execution has grown far from the truth. She was convicted in May 1819 for highway robbery, not murder. She was hanged on February 4, 1820, but another story says February 18, 1820. Lavinia and her husband, John, were hanged on the gallows, which were located on Meeting Street just outside the Charleston city limits.

The best-known tale is that the Fishers owned the Six Mile Wayfarer House outside Charleston in the early 1800s. The story goes that Lavinia would put poison in customers' tea and then rob them. She and her husband would then cut up the bodies and bury them in the cellar. Fisher was believed to be the first American female serial killer. Some stories say that she and her husband killed

several hundred travelers. However, there is no hard evidence to prove that she killed anyone.

Following the execution, Lavinia Fisher was buried in a potter's field near the place where she was hanged. Another story says that she was buried in the Unitarian Cemetery.

Does the ghost of Lavinia Fisher still haunt Charleston? Immediately following her death, people started to report seeing the face of Lavinia floating behind the bars in the window of the cell where she was held. After the 1886 earthquake, reports began to circulate about Lavinia Fisher being seen around the neighborhood where she was held in jail. There were also reports of her ghost being seen in the Unitarian Cemetery.

TWELVE HEADLESS BODIES

Folly Island, like many other places in South Carolina, is no stranger to progress. In some places, the natural beauty of the landscape is

slowly being destroyed in the name of progress. In May 1987, a construction company was doing some excavation work on a construction site on the west end of Folly Island.

Everything was moving along as planned until a body was discovered. Construction on the project was immediately stopped. Thirteen more bodies were unearthed. Construction was halted for about a month while the South Carolina Institute of Archaeology and Anthropology (SCIAA) investigated the strange discovery, and the discovery would only get stranger in time. All of the bodies except one had been buried with their shoulders pointing to the west. What was the purpose of the one body being buried different? Now for the really strange part, though: twelve bodies were missing their head and other important body parts. Some were buried in coffins, while others were wrapped and buried in ponchos. There is no explanation for the positioning of the bodies or the missing heads. There were some artifacts found among the bodies, including Union army eagle buttons, one "5" insignia from a cap, an Enfield rifle and .57-caliber Minié balls.

After weeks of exhaustive research, the SCIAA decided that the men were from the Union army's Fifty-fifth Massachusetts Volunteer Regiment. Still more mysteries followed. There were no other injuries on the bodies, so the cause of death did not seem battle-related. There were several other possibilities for the deaths of these fourteen Union soldiers: illness, head injury or beheading. But why were twelve beheaded and two left intact?

There are several theories about why these soldiers were missing their heads. The rest of the bones were undisturbed, which means that the heads were removed before the bodies were buried. One thought is that the heads were removed by the local islanders for voodoo or some type of black magic ritual. Of course, there's no proof that the islanders ever practiced voodoo. This is just another mystery in South Carolina that will never be solved.

Folly Island is a continuous island stretching from the Stono Inlet to Lighthouse Inlet. That has not always been the case. Many early maps of Folly Island show the island as two separate islands. They were known back then as Big Folly and Little Folly. Historical records dating back to the time of the Civil War note that travel

from Big Folly to Little Folly across the neck of the island was only possible at low tide.

Folly Island played an important role during the Civil War. In 1863, Federal troops began to occupy the island. At one time, more than thirteen thousand Union troops were stationed on the island. At the time of the Civil War, Folly Island was almost completely uninhabited.

Folly Island saw very little fighting during the Civil War. The only fighting to occur on the island was on May 10, 1863. The Confederate forces attacked Federal pickets on the left side of the island. Folly Island was used as a base for Union soldiers during the Civil War. It was also a staging area for the Battle of Morris Island, which took place from July to September 1863. The main shipping channel into the Charleston, South Carolina harbor in the 1700s and 1800s brought ships past the northern side of the island.

The island has also been called Coffin Island or Coffin Land due to its use as a lazarette (a building or ship used as a quarantine station) and leper colony before the war. Some believe that the island got its name from the ships entering Charleston Harbor. The ships would drop off their sick and dying on the island to avoid being quarantined in Charleston Harbor. Many times, these poor, unfortunate people would be left behind to die. Another story is that the name came from a shipwreck that happened near the Folly

Island coast in the 1700s. Many of the bodies of those on the ship washed up on the shore.

In 1832, the ship *Amelia* wrecked near Folly Island while sailing to New Orleans from New York; 20 of the 120 passengers who were on board the *Amelia* died of cholera while stranded on Folly Island. Charleston cut off all supplies to the island fearing that it would spread to Charleston and create an epidemic.

In 1932, only nine families lived on Folly Island. It is now a well-developed island.

THE GHOST PIRATE OF MORRIS ISLAND

Do the ghosts of long-dead pirates still haunt the coast of South Carolina? Do these unearthly visitors still protect the treasure they buried? Will they one day return and claim that treasure?

Long before the Confederate army came to Morris Island, pirates were making stops there to bury their treasure. There are rumors that there are six treasure chests on Morris Island.

Morris Island has a long history of violence and unnecessary death. It was a strategic location during the Civil War. Fort Wagner, also known as Battery Wagner, was a military fortification on Morris Island. Fort Wagner was used to protect the southern waterway into Charleston Harbor.

Morris Island was the site of two battles in the defense of Charleston in 1863. The first assault on Fort Wagner came on July 11, 1863. The second battle was the Union attack on July 18. This battle was lead by the Fifty-fourth Massachusetts Volunteer Infantry. The Fifty-fourth Massachusetts was the first major black American military unit.

After heavy naval and land bombardment, an assault squadron led by the Fifty-fourth Massachusetts Volunteer Infantry went in with bayonets to storm the fort. The assault squadron marched into heavy artillery and musket barrage. Colonel Robert Shaw was killed, and the remainder was driven out with

heavy casualties. The fort held for fifty-eight days under heavy bombardment before the Confederate soldiers abandoned the island on September 7.

Before the battle for Charleston, an army soldier was ordered to move all blacks on Morris Island to Port Royal. The soldier was explaining to a black woman of advanced age that she had to leave the island. During their conversation, she told the soldier about six treasure chests that were buried on her property on the island. She told him that the treasure was buried between two old oak trees in her yard. She said that when pirates buried the treasure originally, one of the pirates killed the other pirate and put his body on top of the treasure chests before covering them up. She said that no one would try to dig up the treasure because the murdered pirate's ghost was guarding it.

In the dark of night, the soldier and one of his friends (with shovels in hand) headed to the two old oak trees. It was a quiet,

peaceful night—not a breeze was blowing. As the two soldiers began to dig for the treasure, the trees began to sway like they were caught in a hurricane. The two soldiers felt no wind and continued to dig for the treasure. As they dug deeper, lightning started flashing. After one particularly lingering flash of lightning, the two soldiers knew that they weren't alone. In the distance, they saw a pirate standing there watching them. The two soldiers dropped their shovels and made a strategic withdrawal. As the legend goes, the treasure is still buried somewhere on Morris Island.

BATTERY CARRIAGE HOUSE INN

The port city of Charleston, South Carolina, is believed to be among the most haunted cities in America. In a city like Charleston, which preserves the remnants of the past, it only seems natural that some of the former inhabitants may still be lurking in the shadows. Ghosts are as much a part of Charleston as the living. Anytime you visit Charleston, you can see tours taking visitors to many of the haunted locations. Everyone hopes to get a glimpse of a wandering spirit. Many times, overnight guests in Charleston will catch a hint of something from the other world. Charleston is full of haunted homes, restaurants, bed-and-breakfasts and graveyards.

The Battery Carriage House Inn is no stranger to these otherworldly visitors. The inn is believed to be Charleston's most haunted bed-and-breakfasts and one of the most haunted in America. This historic place of lodging dates back more than 150 years. Stay at the inn and close your eyes, and take a trip back in time to 1843. Southern plantation homes and crops were as far as you could see.

Samuel N. Stevens purchased the property on which the Battery Carriage House Inn is now located for $4,500. The original home was an impressive house situated among the upper crust of Charleston society. Stevens lived there until 1859, when he decided to sell the property to John F. Blacklock. After the Civil War began,

Blacklock sold his home and all the property to Colonel Lathers of the Union army. After moving in, Lathers hired an architect to renovate the home.

The Southerners in South Carolina did not appreciate a Union colonel living among them and made him feel very unwelcome. Lathers sold the property to Andrew Simonds. Andrew Simonds founded the First National Bank of South Carolina and the Imperial Fertilizer Company. No one seemed to be able to keep the old home. It changed hands a number of times over the next twenty years.

Finally, the Pringle family bought the property in 1920 and converted it into a hotel called the Pringle Court. In the 1960s, the hotel rooms were changed to college apartments. In the 1980s, it was changed back to the old B&B-style building and became known as the Battery Carriage House Inn.

The first reports about ghosts came in 1992. There were two different ghosts: the gentleman ghost and the headless torso. The gentleman ghost is believed to be the son of one of the earlier owners. He was a cultured young man, a college student with a good life ahead of him. Without any notice or apparent reason, the young man went up onto the roof and jumped to his eternal calling. Some rumors say that the young man lost the love of his girl and couldn't stand to be without her.

The other famous ghost is the headless torso. Speculation is that it is the body of a soldier from the Civil War. The Battery was an active artillery installation during the siege of Charleston. Many soldiers on both sides were killed in the city. All of the homes in the area were damaged, and many were abandoned during the four-year conflict. There has never been any indication that the headless torso intends to hurt anyone.

Many other strange things happen, including a glow coming from the bathroom of the inn. On another night, the glow came from the sitting room. The energy masses were in different shapes and sizes and seemed to move around the room. Sometimes cellphones will turn on and off or fail to work correctly. Some people have a feeling of being watched. Others have seen a frosty-looking human face in the mirror or a wispy gray shape of a man floating through a door. People have heard footsteps when no one could be seen. Sometimes, something will move in front of a camera, upsetting the auto focus. A gray shadow of a figure has been seen moving around in a room. It seems that some people moved in or checked in and never left.

Room 3 has strange glowing lights of different shapes and sizes. This usually occurs in the bathroom area. Room 10 has the gentleman ghost. A well-dressed young man's spirit has been seen in this room. Sometimes the spirit has been seen lying down beside some of the female guests. Room 8 has the headless torso. The shutters will open and close by themselves. A frosty human face has been seen in the mirror in this room.

The Battery Carriage House Inn is one of the most romantic inns in Charleston. It has eleven rooms gracefully decorated to complement the time and theme of its historical linage.

Some investigators believe that this type of haunting is a residual haunting. These are not considered ghosts but rather are recordings of energy that have imbedded themselves in a certain location for an extended period of time from some tragic event.

THE OLD EXCHANGE BUILDING AND PROVOST DUNGEON

The earliest record of the land on which the Charleston Exchange Building and Provost Dungeon is located is dated August 1, 1699.

With Charles Town Harbor flourishing and goods arriving from around the world, a new and more modern building more worthy of the main city of the southern colonies was needed. The Commons

House of Assembly of the province (the colonial governing body) petitioned his Majesty's Council for approval of a new building. It chose the most prominent lot in Charles Town for the location of the new building.

On April 27, 1767, the Commons House of Assembly passed the act to build the new exchange and customhouse. By December, the land had been purchased and an agreement with John and Peter Horlbeck had been reached for the construction of the building.

The Horlbecks built what was to become one of the most important buildings in America. It was completed in 1771 on top of the Half-Moon Bastion.

On December 22, 1773, 256 chests of tea were seized and locked in the cellar of the Exchange Building. This was during the Tea Act. The tea remained there until 1776, when South Carolina declared its independence. On October 14, 1776, the tea was sold and the money used to benefit the Revolution. On March 28, 1776, South Carolinians wrote a constitution and declared it publicly on the steps of the Exchange Building.

When the British occupied Charles Town during the last part of the American Revolution, prisoners shared the basement of the Exchange Building with ten thousand pounds of gunpowder that had been hidden there. The gunpowder was never discovered.

Men and women were imprisoned in the Provost Dungeon together. Some were very prominent citizens and others quite common, as well as a few pirates picked up along the way. The sick and healthy were put together.

Isaac Hayne was probably the most notable American to be executed for treason against the Crown. Hayne was held in the dungeon until the time of his death.

On August 13, 1783, with the end of colonial rule, the Exchange Building was assigned to the City of Charles Town, and in the act to incorporate the city, Charles Town became Charleston. The city government worked from the top floor. The open arcade on the first floor was used for business and social gatherings. The second floor served as the city hall. The second would also later become known as the Great Hall. In the 1790 census, Charleston had a population of 16,359.

George Washington arrived in Charleston on Monday, May 2, 1791, and stayed for almost a week. The Exchange Building was the center for all of the official and social events during his stay. On Wednesday, Washington was entertained at a very large and elegant dance at the Exchange Building. There were between 256 and 400 elegantly dressed, lovely ladies attending, and President George Washington danced with each one of them. The number of ladies differs depending on where you get the information.

On February 14, 1818, Charleston sold the Exchange Building to the federal government for $60,000. The Exchange Building served as Charleston's only post office for many years. During the Civil War, the Exchange Building was severely damaged and was going to be torn down, but the citizens wanted the building saved. On July 2, 1870, a newspaper reported that the building would be repaired.

In 1896, all federal offices left the building leaving it empty. On March 4, 1913, the Exchange Building became the property of the Rebecca Motte Chapter of the Order of the Daughters of the American Revolution.

The Exchange Building was used during World War I as headquarters for General Leonard Wood. In World War II, it was used by the United States Coast Guard, Sixth Naval District.

On August 10, 1979, the Exchange Building went through another phase of restoration, and during the process, workers discovered the original wood in the attic.

On October 5, 1981, the Exchange Building and Provost Dungeon were opened to the public. On August 31, 1989, the City of Charleston assumed the management and daily operations of the building. It is now operated as a museum.

Do those tortured souls continue to walk through the Provost Dungeon? What kind of horrifying secrets are buried there? Many people, men and women alike, died horrible deaths there: sickness, drowning (when the water rose up in the dungeon) and who knows what else. The dungeon was filthy and was infested with rodents and bugs.

Many people have reported hearing crying and moaning when they entered the dungeon. Some have reported seeing lights and chains moving by themselves. The employees are dressed in period clothes so it's sometimes hard to tell the living from the dead.

Some visitors have reported approaching someone they thought was an employee only to see them vanish. Others have reported being choked or pushed. People have reported that when they go in the dungeon, the mannequins' heads will be facing one way, and when they see them again, the heads are in other positions. One person reported that once he entered the dungeon, his face started to burn.

I had the pleasure of taking a tour of the dungeon with tour guide Bryan Stewart. Unfortunately, I didn't get to experience any of the paranormal activity. After the tour was over, I did get to talk with Stewart. He does ghost tours, and he told me that on one of his tours, they were in the Great Hall when he saw a lit candle move by the center window. After their tour was over, one of the tour guests mentioned that she saw the candle too.

DOCK STREET THEATRE

The Dock Street Theatre, located in Charleston, South Carolina, was the first theater building designed exclusively for theatrical performances in America. It was built on the corner of Church

Street and Dock Street (now Queen Street). The rich history of the Dock Street Theatre reflects the theatrical and cultural history of the port city from the 1700s to the present.

On February 12, 1736, *The Recruiting Officer* opened at the new theater. For the next two years, the Dock Street Theatre entertained people with a variety of plays and operas. *Flora* was the first opera performed in America and was performed at the Dock Street Theatre.

After the first two years, the fate of the theater is uncertain. It is believed that the theater was destroyed by the great fire of 1740. This fire destroyed also the city's historic French Quarter. In 1809, the Planters Hotel was built on the site of the former Dock Street Theatre. In 1835, the hotel was remodeled, and a wrought-iron balcony and sandstone columns were added.

For fifty years, the Planters Hotel reigned supreme as the principal hotel in Charleston, catering to plantation owners, seafaring merchants and many other travelers. The Planters Hotel is thus noted for some of its more famous employees and guests, like traveling actor Junius Brutus Booth (father of John Wilkes Booth). Robert Smalls, who later became a black Civil War hero, worked as a waiter in the dining room prior to the war. Charleston's famous "Planters Punch" was introduced to America at the Planters Hotel.

After the Civil War, the Planters Hotel fell into a state of disrepair. It was scheduled to be torn down. During the 1920s and 1930s, some of the citizens of Charleston became interested in preserving the city's heritage, and this building was a big part of the heritage.

In 1935, the property was made available to the City of Charleston. At the urging of Mayor Burnet Maybank and local historians, the City of Charleston purchased the old building. The building became a Depression-era Works in Progress Administration (WPA) project. At that time, the present theater was constructed inside the shell of the Planters Hotel. The new structure was modeled after a composite of London's eighteenth-century theaters. Alford Simms, a local architect, re-created the theater with woodwork carved from native black cypress trees or from items salvaged from antebellum mansions. The woodwork and mantelpieces on the second-floor drawing room were salvaged from the Radcliff-King mansion. The renovation of the building cost about $350,000.

On November 26, 1937, the Dock Street Theatre had its second grand opening. The theater opened with a reprise of the first play performed in the original Dock Street Theatre, *The Recruiting Officer*. The play was performed by the new resident performing company, the Footlight Players. Author Dubose Heyward was in attendance for the opening play and was subsequently named writer-in-residence.

The Dock Street Theatre reopened for a third time on March 18, 2010, after a three-year renovation by the City of Charleston. The $19 million renovation brought the theater into the twenty-first century.

There are a number of legends that follow the Dock Street Theatre. This theater is not going to let any other building in Charleston get ahead of it. These legends are of a more unusual nature. They are about ghosts. Since the theater is in Charleston, you know it has to be haunted by at least one ghost and maybe more. One of these unearthly residents is believed to be that of actor Junius Brutus Booth. Another ghostly resident is a lady of the evening whom they now call "Nettie." The ghost of Junius Booth has been seen by actors as he watches the rehearsals from the box above the stage. The legend of Nettie is that she worked in the hotel in the 1800s and was standing on her balcony when she was struck by lightning, meeting her untimely demise. The ghost of Nettie is seen backstage by actors.

THE JOSIAH SMITH HOUSE

The wealthy Charleston merchant Josiah Smith built this house sometime before 1788. It is believed that the house was built in 1785. It is a two-and-a-half-story wood house with a brick foundation. The walls are insulated with brick between the framing timbers. The house is embellished with a semicircular porch.

Josiah Smith built the house in the hopes that it would attract some suitors for his daughter, Mary Smith. For whatever reason, she didn't have many gentleman callers. At least that's the way the story goes. If that's why he built the house, it didn't work. Mary Smith lived unmarried in the house for her entire life. In 1780, Josiah Smith was arrested by the British and exiled to St. Augustine, Florida. After the Revolution, Smith returned to Charleston to continue as a merchant, later becoming a banker.

The current owner (this house is a private residence, so the name of the owner and address has been left out) said that she noticed that the house was haunted from the beginning. The owner had a painter come in and paint the interior. The man reported that he had heard keys jingling but didn't know where they were. The owner's daughter also said that she had heard keys jingling. The owner's daughter and granddaughter were sleeping in the same room one night and felt someone pressing down on them.

The story is that the ghost of Mary Smith haunts the Josiah Smith house. Mary Smith didn't leave her home in life. Maybe she hasn't left it in death.

THE HAUNTED UNITARIAN CHURCH CEMETERY

The Unitarian cemetery is haunted by the ghost of the beautiful Annabel Lee. Like many other Charleston ghost stories, this one includes a sailor, forbidden love, the determination of a man and

woman to see each other against all odds and the return of the ghost of a brokenhearted girl.

Annabel Lee lived in Charleston, South Carolina, before the Civil War broke out. One day, she met a sailor who was stationed at one of the naval bases in Charleston. Like many other such stories, they fell in love immediately. They spent every possible minute together.

One day, Annabel's father found out about the love affair. He didn't approve of the sailor seeing Annabel as he was not up to their social standing. Annabel's father forbade her to see the sailor again. That didn't stop the determined Annabel Lee. She continued to see the sailor every chance she got. She would slip out of the house at night to meet her lover, meeting secretly in the Unitarian Church Cemetery.

For months, Annabel Lee and the sailor were able to see each other in secret. One day, Annabel's father found out about their secret meetings. So, one night he followed Annabel to the cemetery to make sure that his suspicions were right. When he saw them meet, he was beside himself with anger. He locked Annabel Lee in her room for several months. The sailor was transferred to Virginia and never had the chance to say goodbye to Annabel Lee. They never saw each other again. Annabel Lee was heartbroken when she heard the news of her lover being transferred. A few months later, Annabel Lee died from yellow fever.

A friend of theirs got the message of the tragic death of Annabel Lee to the sailor in Virginia. He received permission to return to Charleston to visit her grave. Annabel's father, vowing to keep them apart in death just as he did in life, kept her grave's location a secret from the sailor. The father had Annabel's grave dug six feet deep, while the other graves in the family plot were three feet deep. This would not disturb the other family members who had already been

laid to rest but would disguise Annabel's grave. When the sailor finally arrived at the family grave site, he couldn't find Annabel's grave. All he could do was sit by the family plot.

Many people have reported seeing Annabel Lee's ghost roaming around the cemetery like she is searching for someone. Sometimes she has been seen standing by the family plot.

One source lists the girl's name as Anna Ravenel, age fourteen. The year was 1827. This sources suggests that it was a soldier stationed at Fort Moultrie whom Annabel fell in love with, not a sailor. The soldier's name was Edgar Perry, age eighteen. In 1828, Edgar Perry was transferred from Fort Moultrie. Service records at Fort Moultrie list a man named Edgar A. Perry there from November 1827 to December 1828. Perry enlisted under a pseudonym. His real name was Edgar Allan Poe.

Some believe that Annabel Lee was the inspiration for Edgar Allen Poe's famous poem. Another source notes that Edgar Allan Poe served in the navy in Charleston.

The Ghost of Mary Bloomfield

Another ghost that haunts the Unitarian Church Cemetery is that of Mary Bloomfield. She lived in Charleston more than one hundred years ago. She was happily married, but that would soon come to an end. Her husband had to go to Boston on a business trip and never returned. She never heard from him again. Mary Bloomfield lived the rest of her life alone, waiting for the return of her husband. Today, people claim to see the ghost of Mary Bloomfield wandering around the Unitarian Church Cemetery.

The Unitarian Church

The Unitarian Church is located at 4 Archdale Street, Charleston, South Carolina. Construction was started on the building in 1772 when the Society of Dissenters (now known as the Circular Congregational Church) needed more room than its present location

could provide. In 1776, when the Revolutionary War broke out, construction was almost complete on the church. It is believed that when the British occupied Charleston, they housed the militia in the building. With construction and repairs finally complete on the church, the dedication was held in 1787. It was unofficially named the Archdale Street Meetinghouse.

In 1839, the group was rechartered as the Unitarian Church. In 1852, Charleston architect Francis D. Lee was hired to remodel the church.

Thirty-two years later, the great Charleston earthquake of 1886 knocked off the entire top of the church's tower. Thomas Silloway, a Boston architect, was hired to repair the building. He restored the interior to Lee's original design. The tower was built slightly less elaborately this time.

In 1989, Hurricane Hugo wreaked havoc on the Holy City. The roof of the church was destroyed by the hurricane. The church was repaired to the specifications set by Thomas Silloway and remains almost unchanged.

CHURCH STREET

Church Street in Charleston, South Carolina, is one of the most ghost-infested streets in South Carolina. People say that Church Street is haunted by so many different ghosts because of the level of debauchery that took place in the neighborhood in the early 1900s. Wealthy Charlestonians would hold wild parties with gambling. They would drink incredible amounts of whiskey. Ladies of negotiable affections did very profitable business on Church Street. It is believed that many people violently lost their lives on that street.

Church Street originates at the tip of the peninsula among the mansions of South Battery. Across from the entrance lie the moss-covered oaks on Battery Park, also known as White Point Gardens.

In 1729, twenty-nine pirates from Stede Bonnet's crew were hanged from the limbs of those moss-covered oaks. Their bodies

were left swaying for four days in order to give other pirates a stern warning. The pirates' eyes were fixed, burning into anyone who came by to see them. You could not escape the gaze of the dead pirates because they swung slowly in the breeze, turning in every direction. Many people have reported seeing the ghosts of pirates in this area.

WAMPEE HOUSE

Day slowly fades into darkness as the final remnants of daylight drain from the sky. The crescent moon peeks over the horizon. The chilly fall breeze stirs the colorful, newly fallen leaves. The dull glow from the moon falls on the Wampee House, giving it the glowing appearance of a ghostly house from the past. This is not a ghost house, per se, but it has its share of unearthly residents. This home to the spirits of days gone by is nestled on the point of Pinopolis.

The earliest known date of the home's existence is 1696, when John Stuart received a land grant for one thousand acres. Stuart added additional land to his holdings and ended up with several thousand acres. The primary crops on Wampee Plantation were rice and indigo.

In 1696, Reverend William Screven and others from Kittery, Maine, arrived in the area. In 1698, Stuart conveyed 804 acres to Reverend Screven, thought to be the first Baptist minister to come to the area. Reverend Screven had a dream about founding a haven for Baptists in the area. Screven settled on what is now known as Somerton Plantation. The good reverend's plans didn't work out like he had hoped. In 1704, Screven sold his plantation to Rene Ravenel.

Between 1698 and 1715, Stuart sold more parts of Wampee Plantation. In 1715, Stuart died, leaving the remaining part of Wampee Plantation to his wife and two sons. In 1744, James Stuart, John Stuart's grandson, died and left his part of Wampee Plantation to his wife. There's no record of when or how James Stuart acquired

his part of Wampee. He may have bought it, or it may have been given to him.

In 1749, Gabriel Guignard purchased land from Reverend Screven and later added more acres to his holdings with a royal grant. No date is given for when Thomas Sable bought Wampee. Sable later sold three hundred acres to James Cartonne Jr. No date was given for that sale either.

In 1790, Charles Johnson of Charleston, South Carolina, bought Wampee Plantation. Johnson's daughter and son-in-law, James Macbeth, inherited Wampee when Johnson died. No date was given.

In 1822, James Macbeth died. Soon after Macbeth's death, the present home was built for Macbeth's wife by her son, Charles Macbeth. Charles Macbeth was a Civil War mayor of the city of Charleston, South Carolina. No date is given for these land transactions. Richard Yeadon Macbeth inherited Wampee. After Macbeth's death, his widow, Lou Macbeth, willed Wampee

Plantation to their nephew, William Cain. When William Cain died, his widow received the plantation.

In 1939, work began on the Santee Cooper Hydroelectric Plant. The project displaced many families and communities, and many historic homes were lost when the area was flooded. All that's left of Wampee is thirty-three acres and the plantation house.

There were a number of Indian burial mounds located on Wampee Plantation. The Charleston museum excavated several of them. In one of the mounds, the remains of an Indian were found. Charred bones have been found in other mounds.

One of the legends that surround Wampee Plantation is that the Indians who died in battle there still drop in for a visit from time to time. Another Indian legend is one about the Indian maiden who loved her husband so much that she followed him into battle and did not return. Sometimes, just before midnight on rainy nights, an Indian maid wearing a flowing, almost glowing white gown has been seen standing on the front steps of the Wampee House. One person reported seeing what he thought was a man walking about one hundred yards away who had a shadowy appearance. He walked behind a tree and vanished. Another story is about the ghosts standing on the upstairs landing, with noises being heard. Another story involves the ghost of a girl child dressed in blue. Her portrait hangs above the hearth. She haunts one of the upstairs bedrooms and has been seen looking out of the window. An old pirate whom many believe may have wandered away from his ship at Stony Landing is still hanging around the plantation. Some have reported seeing lights in the windows and a strange sense of being watched.

Many visitors and employees have had their share of spectral encounters. I had the pleasure of a guided tour of the Wampee House with caretaker Sandy Gibson. Although I didn't see or hear any ghosts, I did get some great stories. As we entered the backdoor of the house, Gibson said:

> *Being a southern gentleman and from the South, we always go in the backdoor. I was going in to open up the house. This is where we come in and turned these lights on, then I turned the lights on in that room. Moultrie was with me. A story I like to tell is*

about my black lab, Moultrie. I went upstairs and left Moultrie downstairs. When I got upstairs, I felt something standing behind me. About that time, Moultrie let loose and headed out the backdoor. I turned the lights off and headed out the house. When I got outside the house, the lights were on. Since Santee Cooper's electricity is so cheap, I just left the lights on.

We went into Sandy's office and had a seat. "This is my favorite story," said Sandy.

Santee Cooper was shooting a promotional video with Terry Bradshaw and Steve Mott. At that time, Terry had four Super Bowl rings. I got a call from Terry between 10:00 and 11:00 that night. Terry said I had to come get Steve. He's not staying in this room (he was in the ghost room). He's scared to death. When I arrived, I found Steve throwing his clothes into his bag. I told Terry I'd put Steve in a room in the lodge, and about that time, Terry started throwing things in his bag. I asked Terry if he was going too. Terry replied, "You don't think I'm staying in this house by myself do you?"

We started on the tour. We walked around inside the house, and he showed me a lot of old pictures. He explained what they were, and we headed upstairs. The first room we came to was the ghost room, as Sandy called it. "This is where Steve was staying. Terry was in the room across the hall. This is the picture of the little girl believed to be haunting the house." Sandy pointed to a picture of a little girl dressed in blue hanging over the fireplace. "Just watch her eyes as you move. They follow you." I gave it a try and walked across the room, and the eyes did look as if they were following me.

"The picture was hanging just like this and fell to the floor, breaking the frame and glass. Glass was scattered all over the place. I had to take the picture and have it reframed. Sounds have been heard in here, and things have been moved around in here. We had a group of people staying in here one time. At about 4:00 in the morning, they heard a little girl laughing and giggling in the hall. No one saw anything."

We headed back downstairs and out on the porch. We were standing on the porch near the steps. "We've found some medicine bottles under the house," Sandy said.

Dr. Hardcastle lived on one of the tracts that now make up Wampee Plantation. Hardcastle served as a surgeon in the British army during the Revolution. This was the end of my interview and tour, so I packed up the papers Sandy gave me, shut down the recorder and headed home. I did get an invitation to go back.

MIDSTATE AND MISCELLANY

LONGSTREET THEATRE

The capital city of Columbia is rich in history and folklore, and it is also no stranger to ghost stories. Columbia, like many other towns in South Carolina, plays host to many unearthly visitors; they have decided to remain here instead of traveling on, or maybe they have lost their way. I guess we'll never know their purpose for remaining here, but they have for hundreds of years.

One building in Columbia that is home to many strange and unexplained occurrences is the Longstreet Theatre. It is known as one of the state's most haunted buildings, and no wonder, considering its rich history. The building was designed and built along the lines of a Roman temple. It was built in 1855 as a chapel for South Carolina College. From its inception, the building seemed to be ill-fated. The building was completed two years late. The roof blew off twice. The acoustics were poor at best and seemed to be uncorrectable, apparently.

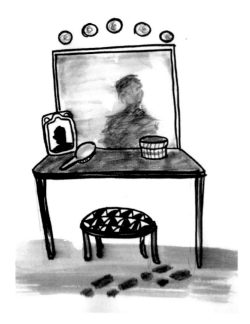

The building was used as a hospital during the Civil War. It was used for both Confederate and Union troops. It is believed that the hospital morgue was housed in the basement, which is three barrel-vaulted alcoves made out of brick. This has been converted into the greenroom for the theater. During its use as a hospital, many Confederate and Union soldiers lay sick, injured and dying. Without proper medicine and medical equipment, many soldiers died agonizing deaths.

From 1870 to 1887, the building served as an arsenal and armory for the adjutant and inspector general of South Carolina. In 1888, it was converted into a science facility, and in 1893, it was converted into a gymnasium.

The building came close to being torn down in the early 1970s. In 1976, the building was remodeled into a theater. The building had finally found a purpose that would complement its architectural grace. The two-story building was renovated into a four-story building. It features a circular stage surrounded by seating. It also includes an effects sound system and a hydraulic stage. The main entrance is now in the back of the building. As you approach the entrance, you are greeted by a graceful courtyard.

Many people believe that the haunting at the Longstreet Theatre relates directly to it being used as a hospital during the Civil War. One ghostly report comes from the basement. An actor was down there near the greenroom when she felt a sudden wave of fear overtake her. As she looked toward the greenroom, the temperature suddenly dropped, and she felt the cold air hit her. There were no

open doors or windows in the area to let in a cold draft. She also reported a feeling of being watched. Other actors have reported feeling cold wind blowing and hearing strange noises, as well as feelings of being watched from the greenroom.

Some have reported footsteps in an empty hallway and sounds coming from dark, empty rooms. One actor reported that he could feel some sort of vibrations. Some believe that these are the ghosts of the soldiers who died in the hospital.

The strange happenings continue at the Longstreet Theatre, but as they say, "the show must go on."

SOUTH CAROLINA AND ATLANTIS

Researching a book will take you down many roads that have no end and to many places you never expect. You never know what or who you will find at the end.

Is the mysterious disappearance of Atlantis connected to South Carolina? Whatever may have been the cause of the disappearance of the fabled island of Atlantis, did it have an effect on South Carolina? Atlantis was first mentioned by Greek philosopher Plato (427–347 BCE). The date of the disappearance of Atlantis is still heavily debated. It is also debated whether Atlantis ever even existed. We may know the answer to that in the not-too-distance future. Some believe that Atlantis disappeared about twelve thousand years ago.

In 2007, planetary geology professor Peter Schultz and a team of scientists from Brown University in Providence, Rhode Island, presented evidence that an extraterrestrial body (a comet or an asteroid) impacted the earth or exploded over it 12,900 years ago. There is no conclusive date for the disappearance of Atlantis, though; 900 years one way or the other is not that important when you are dealing with this amount of time. Some believe that this impact or explosion caused the disappearance of this mysterious island.

At the end of the Pleistocene era, woolly mammoths, giant sloths, saber-toothed cats, lions, tapirs and the teratorn—a condor with a sixteen-foot wingspan—roamed North America. About 12,900 years ago, these animals—along with human remains—disappeared from the fossil record. What caused the extinction of these living creatures so suddenly is still a mystery. Was it an impact from an extraterrestrial body?

Some scientists believe that the evidence of this impact is hidden in a dark layer of dirt called the black mat. The formation of this layer dates back 12,900 years. The black mat is only three centimeters deep but provides an enormous amount of information. It is filled with carbon, which gives it its color. The scientists ran geochemical analyses and carbon dating tests to determine the makeup and age of the black mat. The date of the black mat coincides with the abrupt cooling of the Young Dryas period. This black mat has been found in archaeological sites in California, Arizona and South Carolina.

Directly beneath the black mat, researchers found high concentrations of magnetic grains containing iridium, charcoal, soot, carbon spherules, glasslike carbon containing nanodiamonds and fullerenes packed with extraterrestrial helium.

Professor Schultz said that the most compelling evidence was the nanodiamonds. These can only be formed from the intense pressure of an extraterrestrial impact. With this information, we now know that something of extraterrestrial origin impacted the earth, causing great destruction.

Some scientists postulate that this comet or asteroid crossed over North America, scattering debris along the way and creating the oval-shaped craters known as the Carolina Bays before crashing into North America or the Atlantic Ocean. There is a possible impact site known as the Nares Abyssal Plain.

Blast Cemetery

Conclusive information on Blast Cemetery seems fairly elusive. However, the small amount of information I could find is filled with a lot of mystery. During clear nights, at midnight, you can hear gunshots and cannon fire. If you look in the direction of the sounds of the gunfire, you can see people fighting.

If you run, there will be people or things with red eyes and bloody teeth chasing you, and you'll hear a voice say, "You are a killer. You must die." Some people have been injured, and some have just plain disappeared. One report advises that you never stop near the cemetery or there could be dire consequences.

I could not find the location of this cemetery or any independent information to confirm this. This is probably just a campfire tale.

INTERVIEWS

DAVID BENNETT

This is an on-camera interview I did with David Bennett when I was filming A Storied Journey Through South Carolina's Mysterious Past in Myrtle Beach, South Carolina.

My name is David Bennett. I live on Little River Road in Myrtle Beach, South Carolina. This is a portrait of my great-great-aunt, Nancy Elizabeth Hickman, better known as "Aunt Sissy."

She was born in 1868 in a little community plantation known as Hickman Branch just across the state line in North Carolina. She died in 1878 of a fever, and it depends on who is telling the story whether it's scarlet fever or whatever kind of fever. It's just always been, "She died of a fever." Just before she died, according to family stories, during the fever she would scream and holler for her mother, which was my great-great-grandmother, Nancy Marlow Hickman. Every time, my great-great-grandmother

would go to her and tell her, "I'm here. I'm here." She didn't recognize her.

Aunt Sissy died in 1878 and was buried in the family plot in Hickman Branch. Around that time is when the picture appeared in the family. No one really knows where it came from or what was going on. My great-grandmother, who was Sissy's sister, told the story that she remembered as a little girl, a traveling photographer coming around before the time of Sissy's death, taking pictures of different people in the community. After that is when a lot of family pictures just popped up.

After Sissy died, the picture stayed in the family. When my great-great-grandmother died, the picture passed to my great-grandmother, Iretta Hickman Long, otherwise known as "Rhett." There were strange things that begin to occur around the picture within the family. The joke was that Aunt Sissy did it.

When my great-grandmother passed away in 1966, the picture passed to my grandmother, Bula Bennett. The picture hung in her dining room, and everyone that saw it talked about Aunt Sissy. Later on, the picture was given to my uncle, who had built a house in Wilmington, North Carolina. He needed some family pictures to go up by the staircase. The picture of Aunt Sissy hung at the top of the stairs. Around 1986 or 1987 is when my grandmother got the picture and gave it to me. The picture stayed in storage in my parent's home until 1995, when I graduated from college and got my first job and moved to Myrtle Beach, South Carolina. I brought the picture with me because it is a very nice picture and is in the original frame, and I thought, "I'll hang it on my wall." After going around and trying to find a spot for the picture in my new apartment, I couldn't find a space where it would fit. I looked at the picture and jokingly said, "All right Aunt Sissy. I'm going to have to pack you away. I don't have any place to hang you." I put the picture on the floor against the wall and left it.

Later that night, I went to bed. Later that night, I was awakened by something or someone hitting me on the arm. When I rolled over and looked, there was just a blur went out of the room. I remember laying there thinking, "There's someone in here." I got up and looked around. All the doors were locked. I chalked it up to being just a dream and went back to bed.

The next morning, when I got up and got ready to take my shower, I pulled my shirt off and noticed there was a bruise on my arm where I thought I dreamed someone had hit me. After that, I looked at the picture and figured out that Aunt Sissy must have done it. After that, I found at spot for her on the wall and hung the picture up. After that, I really didn't have any other major incidents for the five years I lived there.

There were a couple of little things that happened. One morning, when I was making a sandwich to take to work for lunch, my bedroom was just off the kitchen, and while making my sandwich, I heard a *click* like the doorknob clicking, and I noticed my bedroom door sliding open. About halfway open I yelled, "Sissy, stop it!" When I did that, the door stopped right then. I went and tried to open it, but it wouldn't open. For it to open, the doorknob had to turn. I tried to get it to stop in the exact spot but couldn't unless I physically stopped it there. So once again, I had a "Sissy moment."

Another incident that occurred in my apartment with Aunt Sissy's picture is when a friend of mine came to town for a job interview and stayed at my place.

The next morning, when I was leaving to go to work, my friend who had slept on the couch made the comment, "Could you turn on the TV for me?" So I said, "Ok," and turned on the TV, and I left. Later that afternoon, he called me and said he was never coming back to my house again. There is some strange stuff going on here. I asked what. He said when he woke up the TV was off, but he heard a buzzing sound coming from the bathroom. When he went into the bathroom to check it out, he saw my electric razor on and moving around on the sink but would never fall off. He grabbed it and turned it off. He has never come back. He said the picture freaks him out.

After that, for the next couple of years, I didn't have any problems until I was getting ready to move to the townhouse that I currently live in today.

I had about ten people helping me move. We had three trucks and an assembly line set up for moving. By the end of the night, we had everything. We were getting ready to make the last trip. I gave instructions to leave all the family pictures, including Sissy's, back at

the apartment. I would go back and get them the next day. I didn't want anything to happen to them. On the last trip, I was standing on the steps of my new apartment. All of a sudden, every truck and everybody came. My best friend got out of one of the trucks and said there's been a "Sissy moment." A car pulled up, and two guys that was at the apartment were in it. One of the guys said, "I'll never go in your apartment again. There's been a 'Sissy moment.'" I was trying to figure out what had happened when he said Sissy turned the kitchen light on.

After everything calmed down and we got something to eat, we went back to the apartment. You could tell they left in a hurry. The front door was wide open, the kitchen light was on, there were things kinda thrown around and, of course, Sissy's picture was still there. The next couple of weeks, I was talking to one of the guys that were there, and he finally owned up to what happened. He and the other guy was looking at Sissy's picture and started joking with her, telling her that "David doesn't want you anymore. David going to leave you here, and you'll be in the dark. You're going to be all shut out." Right at that moment, the light turned on. Apparently, she was letting them know that she can turn the lights on and she won't be in the dark at all. After that time, every time one of the guys comes over, they stop at the bottom of the stairs and look at the picture and tell Sissy hello. After that, there were just little incidents while I was here, nothing really big.

I have a cat named Emily, and she likes cat toys. There was one little toy that she liked to play with that made a rattling noise. One morning, I was in the kitchen, and I kept hearing that toy go *rattle, rattle, rattle*. I was thinking, "My cat is tearing that toy apart." I yelled Emily, that was my cat's name, stop it. I heard a *meow* and looked down, and Emily was standing at my feet. When I walked around to the stairs, the rattling stopped. There was the toy, and nothing was going on. I took the trash out to the dumpster and returned to the kitchen. Then I started hearing the toy rattling again. At that time, I got my keys and walked out.

I have not had any more incidents since then, but my next-door neighbors told me that they have seen a little girl in their apartment that looks and is dressed like Sissy.

LUKE ANDERSON

The Burroughs Company Lower River Warehouse was built in 1880 on the Waccamaw River. It was used as a terminal for the Waccamaw line of steamers operated by the Burroughs and Collins Company The steamers ran until 1919. The warehouse was vacant for about forty years. It has been converted into a meetinghouse but the interior and exterior appearance has been retained. Terror Under the Bridge is a themed Halloween tour in a haunted building. It was started in 2005, with proceeds going to charity. The following interview is with Luke Anderson.

There are some things that I can't explain in here. When me and my partner, Gene, were working in the warehouse and one would leave, after a few minutes, you would hear footsteps and other unexplainable sounds. You could here the footsteps so good that you thought the other person had returned. You would call out only to find no one was there. We had to start letting each other know when we returned.

There are several areas in the building that the actors refuse to work in. [Luke Anderson and interviewer James Ebert walk into another room.] This is where we have the fog machines set up. Another actor will be in that room [Luke pointing to the next room], where we can make eye contact with a mirror. One night, the actor in the next room kept getting scareder and scareder. I noticed the actor wouldn't go into the room where I was with the fog machines. When he would go on break, he would go the long way around. When I ask him why, he said, "Don't you see the fog?" I hadn't noticed it, but the fog was moving in the opposite direction. With the window and door open and the draft coming in, the fog should have been blowing back into the building. It wasn't; it was blowing against the draft.

A lot of actors have felt a cold chill in another room. [Luke Anderson and James Ebert move into that room. Anderson points to the area of the cold spot.] This is the place no actor wants to stay long. They say the longer you stay here, the colder it gets.

[Interviewer James Ebert:] When we were in the other section talking, I was facing in this direction, and I saw something moving

from left to right across this window. When I went to investigate it, I found the window was about fifteen feet up and there was water under it.

[Anderson points to another area and says that at times on the other side of that wall, it sounds like a hammer falling. When you go to pick it up, there's nothing there.]

Results of the Recordings by Sherman Carmichael

When we first arrived at the Lower River Warehouse at about 7:10 p.m., the first thing I did was set up a digital sound recorder in the loft. It was left to record until we had finished the interview. I played the recordings on the way home, about an hour's drive. The only unusual sounds on the recording were footsteps. You could clearly hear footsteps moving around in the loft.

ANGIE WILDER STONE

My dad passed away at the end of November or first of December. Some years later, it was a very cold, wet morning, and I was on the way to see a family member over near Lake City. I came up on a hitchhiker on the side of the road. Normally, I don't stop for hitchhikers, but something made me pull my car over. When I pulled over, before he got into the car, I could smell the scent of a wood-burning stove. My daddy always had a wood-burning stove in his house. When the man got in, I didn't feel scared at all. I spoke to him. The man said he'd been down on his luck: he had lost his job. "I just need a ride up to the store."

I got a different feeling when he got into the car. It was like my daddy was in the car with me. We came to a store at the crossroads, and I pulled in. I asked him what kind of work he did. He said he was a welder and a pipe fitter, and that's what my daddy did all his life. When he got out of the car, he kind of bent down, and said,

"I want you to know everything is going to be all right." My daddy always bent down like that when he got out of the car and had something to say. He said, "I want you to know that you're a good person." I never got a chance to tell my daddy goodbye. I felt like that was my daddy's way of talking to me.

When he walked inside, I picked up the phone and called my cousin and let her know where I had picked this gentleman up at and where I'd taken him. She said, "Angie, nobody has lived in those trailers where you picked him up at for years and that store has been closed for five to ten years." I said when I pulled into the parking lot it looked like a running store. She said, "I'm just telling you, that store has been closed for years." There were cars in front of the store.

I have never seen this man again. I've asked around, but nobody ever seen him or knew him. I felt like it was my dad. The store was called Norwoods Grocery when it was a running store.

I've been back to that store several times, and it's never reopened. There's a house that sits to the left where an older lady lives. I've pulled into her drive and asked her about this man, and nobody knows what I'm talking about. There was no way that in 1999 this store was running.

I could take you back to the same place on the road where I picked him up. I can still tell you how it smelled and how he looked to this day. I have never experienced anything like that in my life. It was a very cold, wet day when I picked him up. When he got into the car with me, it was almost like a sudden temperature change. The temperature went down in the car.

I was very comfortable with him in the car. It was like I didn't want to look at him. I never looked directly at him, not in the face. It was just like I knew my daddy was in the car with me.

We never passed another car or seen a person on the way to the store. There were cars in the store parking lot. It looked like an operating store. There were vehicles there. But every time I've went back, there's never been a car there.

When I tell this story, my heart feels so full because I believe that it was my last encounter with my daddy, and it was after his death. The store looked like an old family country store.

BARBARA BUSH

My husband and I bought this house in 1993 when we moved from Fort Worth Texas to Georgetown. This house was built in 1903. My husband and I didn't know it was haunted when we moved in. The previous tenants didn't tell me about the house being haunted. Of course, I would have bought it anyway. I'm not afraid of spooks.

There were several instances that made us realize that there was a ghost in the house. We just accepted it and named her. I named her after King Author's evil half-sister whose name was Morgan le Fay. So I just named her Morganna.

Her biggest thing is to take things and hide them for about six months. Then she brings them back. I can't tell you how many things I've had disappear and then reappear in about six months. It started out one morning with my husband when he got up. He had a big chest of drawers that he kept his clothes in. He pulled open the drawer where he kept his underwear. He called down to me and asked me what happen to his jockey shorts. He said the drawer was empty. I told him I had washed yesterday and the drawer should be full. This was the first incident of things disappearing. So I went down to the store and got him some new ones. I bought him six more pairs. About six months later, she brought all the old ones back. He got up one morning, and there they were. This started about a month after we moved in. I can't remember the month; my memory of the past is not super.

The next incident was with my husband's tobacco jar. It was glass covered with leather and had been in the family for years. He would have it sitting by his chair and would come down in the morning and have his coffee and a smoke. One morning, he came down and the tobacco jar was missing. He said, "What did you do with my tobacco jar?" I told him I didn't do anything with it. He said, "Well, she's got it." About six months later, it reappeared. He came down one morning, and there it was. She keeps things about six months.

Later, I found out that some people that rented this house before us had an experience. She was a schoolteacher, and she left her car keys in the same spot all the time. She came down one morning, and the keys were gone. She told me this long after we moved in.

She said one morning she got up, and her keys were not there. She searched for them but couldn't find them anywhere. She had to use her spare keys. She come home and was making up her bed, and under the pillow was the keys. She [Morganna] put them under the pillow, so it didn't take six months to get her keys back. She said there's a little closet upstairs with a snap lock on it that can only be locked from the outside. She came home one evening and couldn't find her cat. She kept hearing him cry but couldn't find him. She finally found him locked in the closet. Obviously, Morganna had locked him in the closet. They just accepted it that she was there; it didn't bother them much.

She [Morganna] does talk to me over the phone but not in a voice. I come home one day from a visit to Texas visiting my children. I had a terrible trip—missed the plane and they lost my luggage. That trip was one of those horror stories. I came in and plopped down in this chair and said, "Morganna, did you miss me?" My phone went *beep, beep, beep, beep*—that was her answering me. I guess she did miss me.

It doesn't bother me that most people think I'm a little weird. I guess it's because they've never lived with an entity before. I'm not afraid of ghosts. I'm more afraid of people who's alive than of the dead. There's a lot of bad stuff out there. I'm more afraid of that than I am of her. I just live peaceably with her.

After I fell one day and was hospitalized, I was on a lot of medication for pain and who knows what else. One morning, my friend—sorta my keeper or whatever you call it—came over to fix my medication and said that one particular medication was gone. It was on top of the chest with the rest. It disappeared and didn't take six months to reappear; it took about three weeks. I said, "Morganna, I need that medicine," and she brought it back in about three weeks. She's not evil at all. I think she's a poltergeist. You know the German definition for poltergeist is playful ghost.

I don't know if any of my animals see her or not. I have a bird named Norman and a dog named Foxy and another bird and a cat. I keep seeing my dog Foxy looking up the stairs like she sees something.

If Morganna is the worst thing I have to worry about, I'm not going to worry. I don't know where she came from or who she is.

I've got a list somewhere around here of all the people that have lived in this house. One day, I'm going to sit down and start reading the names and say, "Morganna, give me a signal if that's you." I've never seen or felt anything, but I know she's here. Like I said, she doesn't scare me. I've never smelled any perfume or unusual smells. She's very undetectable except for taking things.

Several weeks ago, another bottle of medicine got missing. I asked her to return it, but she hasn't. Morganna sure makes life interesting.

Morganna, if you want to talk to these gentlemen just beep the phone. The only way she corresponds with me is by beeping the telephone. I don't hear any voices or footsteps.

There's a theory that when Georgetown was 90 percent black, with the slaves, that the slaves brought over their voodoo. I don't know about that, but if you notice, many of the old homes in the historic district has their ceiling painted light blue. That's called "haint blue." That's supposed to keep out the haints, but it didn't work in my case. See, my ceiling is painted haint blue. I just take her as Morganna the friendly ghost.

One day, a paranormal group wanted to investigate Morganna, I told them they were not coming in my house and bothering my ghost. I would never think of trying to exorcise her. These spirits are trapped in this time for a reason. They can't seem to make their way back. I'd love to help her make her way back, but I don't know how, and I'm certainly not going to have an exorcism in this house.

I had a short housecoat disappear one day, and I asked her to bring it back—that I needed it—and she brought it back the next day.

I'm a painter, and the only time that I've felt the presences of a ghost was one night when I was trying to do a portrait of my father from a picture because my father had passed on. I was trying to get the features right and having a terrible time with it. Then, all of a sudden, I felt something brush against my shoulder. Obviously, it was my father trying to tell me how to paint it. I had been struggling with it, and when I finished it, I took it to class and the instructor asked how I finished it. He said it was perfect. I told him I had a little help. It was my father. I felt his presence so strong it was unreal. I've never felt it again, but he helped me finish that painting and it's dead on.

At 11:15 a.m. during the interview, Barbara said, "Morganna, if you want to talk to these gentlemen just beep the phone." The phone didn't beep, but the door between the parlor and sitting room opened about halfway just as if someone had walked into the room. It did not close back. After the interview was over, we walked into the parlor, and I tried the door. Once the door is closed, it latches. The handle has to be turned to open it. The door will not move on its own. There were no doors or windows open for a draft to blow the door open.

ABOUTTHEAUTHOR

Sherman Carmichael was born in Hemingway, South Carolina. He moved to Johnsonville, South Carolina, in 1981. He has spent twenty-four years in law enforcement. His interest in strange and unusual things began when he was sixteen or seventeen with a copy of *Fate* magazine. Since then, he has written many articles on haunted locations for various newspapers. At age eighteen, Carmichael began investigating haunted locations around South Carolina.

In 2011, Carmichael's first book, *Forgotten Tales of South Carolina*, was published by The History Press. In 2012, Carmichael's second book, *Legends and Lore of South Carolina*, was also published by The History Press. Carmichael still investigates haunted locations in South Carolina and other states. He has also worked in the entertainment business for twelve years as a talent agent.

Visit us at
www.historypress.net
..
This title is also available as an e-book